Modern
Oil Impressionists

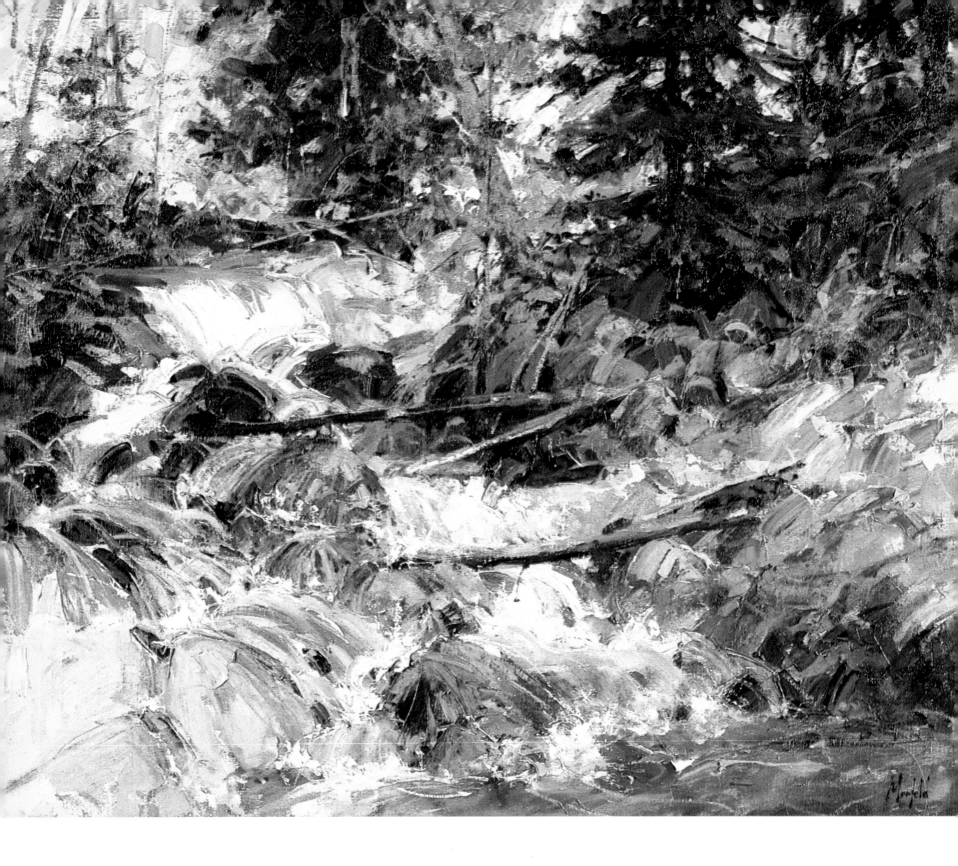

Modern
Oil Impressionists

RON RANSON

David & Charles

Acknowledgements

◁ *FRONTISPIECE:*
RAINBOW'S DELIGHT BY GERALD MERFELD
I chose this particular painting to appear at the fore of the book as I feel it has everything an Impressionist painting should have – immediacy, rich colour, exciting design and movement – while still allowing the viewers to be active in interpreting the scene. Notice also the varying angles of the trunks – no two are the same.

Producing this book has, again, been like a world-wide treasure hunt, coaxing artists to part with their precious transparencies and getting their help. In the order in which they appear, I would like to thank very sincerely: Maxwell Wilks, Diana Armfield, Gerald Merfeld, Trevor Chamberlain, Don Stone, Ken Howard, Doug Sealey, Everett Raymond Kinstler, Sir Roger de Grey, Dale Marsh, Delbert Gish, Paul Strisik, Ian Houston, Walt Gonske, Arthur Maderson, Pier Baffoni and Lee Gordon Seebach. Without their willing co-operation, this book would never have happened.

I designed the look of this book at home, in St Briavels, pursuading friends and neighbours to help. Ann Mills has helped me enormously with the writing and editing, Jenny Hickey did all the typing from my almost indecipherable scribblings, and Ray Mitchell has done much of the photography for me.

NOTE
I have included the sizes of the paintings wherever possible, but this information has not always been available.

A DAVID & CHARLES BOOK

Copyright © text: Ron Ranson 1992

First published 1992

Ron Ranson has asserted his right to be identified as author of this work in accordance with the Copyright, Designs and Patents Act 1988.

British Library Cataloguing in Publication Data

A catalogue record for this book is available from the British Library.

ISBN 0 7153 9974 8

Typeset by John Youé
and printed in Italy
by OFSA S.p.A. for David & Charles
Brunel House Newton Abbot Devon

Contents

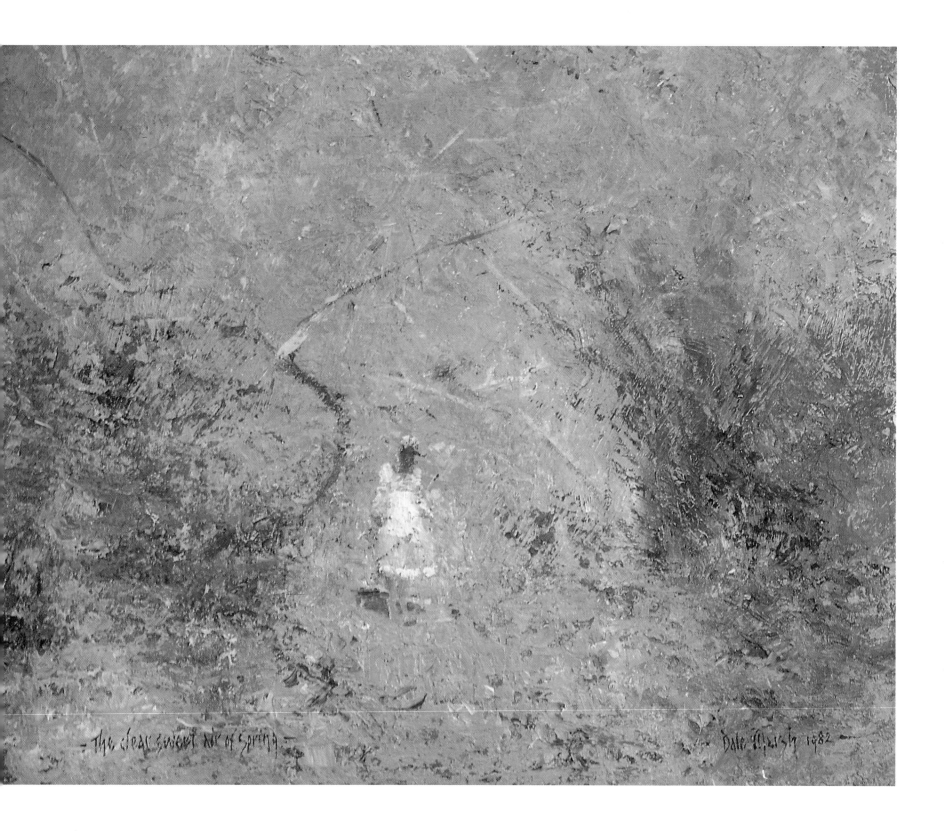

- The clear sweet air of spring - Dale Marsh 1982 -

6

Introduction

There's no doubt about it, in any public gallery in the world the Impressionist rooms are always the most crowded. Virtually everyone, regardless of class, responds to the spontaneity of these works of art. They appeal to us all directly, with no need of theory or explanation to interrupt the pure pleasure of looking at them. Through our modern eyes they give us the illusion that we could almost have done them ourselves. As well as all this, the subjects themselves show scenes of enjoyment and fun – it's all heady stuff! But wait – it couldn't have been that easy. In reality, it took years of struggle and practice to achieve the spontaneous look and the appearance of effortless ease that the first Impressionists created.

It is certainly true that the art of painting has never been the same since the French Impressionists broke away from the accepted classical style, where works were painted in the studio within strict rules and with inflexible teaching methods. The Impressionists, on the other hand, literally brought painting out into the sunshine and fresh air.

The title of this book is *Modern Oil Impressionists*. I had toyed with the alternative titles of 'Present Day' or 'Contemporary'; what I really wanted to do was differentiate it from the hundreds of books about the French Impressionists – this period of art has probably been discussed and written about more than any other in art history. Having said that, it is impossible in a book of this nature not to go back and discuss what is, after all, the root of modern-day Impressionism.

Theodore Durel described the Impressionists at work as far back as 1878:

> The Impressionist sits on a river bank. Depending on the weather, his angle of vision and the time of day and whether it is windy or still, the water takes on every possible tone and he paints unhesitatingly by the water with all its tones. When the sky is overcast, on a rainy day he paints sea-green, heavy, opaque waters; when the sky is clear and the sun shines, he paints sparkling silvery-blue water; when it's windy he paints the reflections made by the lapping waves; when the sun is setting and darts its rays over the water, the Impressionist, to capture the effect, lays down yellows and reds on his canvas.

In order to capture a certain light or atmospheric effect, the Impressionists used their colour scientifically, by applying complementary colours adjacently, thus placing reds with greens, blues with oranges, and yellows with violets. These theories all began with M. E. Chevreul, a French scientist who was interested in art. His research led to his writing a book in the mid-nineteenth century entitled *Principles of Harmony and Contrast of Colours*, in which he presented his theories of mix contrast and simultaneous contrast. It later became a 'bible' for the Impressionists. They applied the pigment in short, broken strokes (a method now termed 'broken colour'), which made their paintings much brighter, lighter, and more airy than in previous styles. Colour took a giant leap forward with this movement, and we are still feeling its effects today. At the time, however, the paintings' sense of immediacy was the basis of their condemnation by the Paris Salon and critics who felt that the paintings were unfinished.

There are, however, always two sides to a coin and some of the mystique that has been built up around these painters has proved to be exaggerated. The legend that the Impressionists painted *en plein air*, usually in one go, has been handed down from generation to generation. Monet, for example, made the most strenuous efforts to maintain the fiction that he painted 'as free as a bird sings' to the point of deception. Yet this was often not the case.

There was a fascinating exhibition held at the National Gallery in London recently

◁ THE CLEAR SWEET AIR OF SPRING
BY DALE MARSH
12 x 15in (31 x 38cm)
There's a lovely sense of mystery in this painting for, although the picture is bathed in sunlight, much has been left to the viewer's imagination. Although every colour in the spectrum seems to have been used, they have been handled with masterly restraint to produce a truly impressionistic painting.

called *Art in the Making*, at which fifteen of the main Impressionist paintings were put through all manner of scientific processes such as X-rays, infra-red photographs, microscopic analysis of tiny fragments of paint, and chemical analysis of the pigment, in an attempt to reveal some of the Impressionists' secrets. This investigation proved that most of the paintings were subject to second thoughts and alterations back at the studio. Of all the paintings examined, only one, Monet's *The Beach at Tranville,* was completed at a single sitting *and* outside (revealed by the grains of sand adhering to the paint surface). Another painting, Renoir's *The Umbrella,* was actually painted in two stages about five years apart, the chemical study of the pigments confirming the dates of areas and the areas of change. This analysis was made easier because the final years of the nineteenth century saw a rapid development in paints and pigments which of course the Impressionists were quick to adopt – such as bright permanent paints, ready ground in tubes, which gave new scope for their palettes and improved portability of materials out of the studio.

In 1874 Monet, Renoir, Sisley, and Pissaro held their first Impressionist exhibition in Paris. About 11 years later, and thousands of miles away in Australia another revolutionary movement, almost equally dramatic, happened. It was the first great flowering of Australian art, and became known as the Heidelberg School. There, a number of young, intensely nationalistic painters gathered together and put aside traditional methods to evolve their own truly Australian vision.

The main artists involved were Roberts, Streeton, McCubbin, Lauder, Davis and Withers. Before their time there was a tradition of Colonial painting. This was a modification of the rigid, formalised European academic style of painting to suit Australian conditions. The Heidelberg School signified a moment of change to national independence – a new and different kind of painting which has shaped Australian vision ever since. The period of the School proper was only 18 years, and the 'high period' was even briefer and more intense – from 1886 to 1889. During this time a group of artists worked together in a series of painting camps – probably the most momentous period in all the artists' lives. The result was the *9 x 5 Exhibition* in 1889, so called because many of the paintings were painted on 9x5in cigar-box lids, which made ideal canvases. Most historians now agree that although the painters were aware of at least some of the French Impressionists, the Heidelberg School owed little or nothing to their direct influence. Although far less publicised than its European counterpart, the School was in its own way just as revolutionary. Its duration was short, but the influence on Australian Impressionism was to last for decades, its best work still ranking among the masterpieces of that country's paintings.

Americans, too, were greatly influenced by the Impressionists. Here an important link was Mary Cassatt who came from a wealthy Pennsylvania family. In 1868 she travelled to Europe to study as a painter. After travelling in Italy, Spain and Belgium where she studied the Masters, she eventually arrived in Paris and fell under the influence of the Impressionists and in particular had a mentor in Edgar Degas. Her oils and pastels were similar in handling and composition to those of Degas and she incorporated the colour theories of the Impressionists – many of her works show delicate use of complementary colours. On her return to America, she encouraged many American collectors to purchase the French Impressionists' work and her influence is one of the reasons that present day American art museums have such wide ranging and excellent examples of French Impressionist art.

At this point, perhaps I can explain how I came to write this book; so before we go any further, I'll tell you a little about myself. It may sound like a paradox, but life really began for me at the age of fifty when I lost my job through a company takeover. Until that time I'd mixed careers in engineering and advertising and finally finished up with a foot in both camps as a publicity manager for a large engineering group. Later, out of work but undaunted, I taught myself to paint in watercolour, mainly from books, of which I am an avid collector. (I must now have one of the largest 'how to paint' libraries in the world, acquired from every country I visit.)

Enjoying painting as I did, I had an enormous yearning to communicate this joy to everyone – rather like an old-time evangelist – and communication became my main priority. It started in a small way with talks in village halls, articles in art magazines, and running my own residential painting school. This gradually developed into books, videos, and worldwide teaching in places such as Australia, Greece, Brunei, France, South Africa and all over the United States. Now, ten books later, I'm still excited about painting and other painters.

My first book on Edward Seago proved to be a huge success and opened the floodgates to a whole new type of book for me. Like everyone else I needed, and still need, role models and heroes to inspire and motivate me – men and women who produce work

more developed than mine, without becoming remote figures. I needed those who gave me the feeling that if I only tried a bit harder and thought a bit deeper, I could achieve similar results. Everyone has intellectual parameters and personal tastes; I personally wanted to look at paintings that weren't too detailed and painstaking or alternatively, at the other end of the scale, so advanced and abstract as to be almost clinical. I wanted also to see honest and painterly brushstrokes which were true to that particular medium, not carefully smoothed over and polished out of existence. Moreover, I wanted paintings which involved the viewer in the artistic process, allowing them the opportunity to exercise their own imagination and intellect.

Although I knew from my experience and contact with my students that thousands of others shared my tastes and aspirations, there seemed to be far too few publications that met this demand. There was a vast area between intellectual élitism and what I felt was flat-footed banality. This was the area I would try to fill. I persuaded my publishers to let me produce a book called *Watercolour Impressionists,* which was a collection of 'free' watercolour artists, worldwide, whom I admired. I must emphasise that they represented my own personal taste and choice of artists, each with their own contrasting approach to their subject but all of whom in their own way had produced a quality which invited the viewer to participate intelligently. I think the formula worked; at any rate my readers liked it and, what was just as important, my contributing artists were pleased. So we come to this volume.

During the fifteen years I have been painting, watercolour seems to have gradually overtaken oil painting in popularity with the thousands of leisure painters. Many more instructional books and videos have been published on the medium of watercolour – now I feel it's time to redress the balance. In this book I've collected some of the world's best 'free' oil painters. Again, not those who are remote in their approach, but those who produce work which looks (I did say 'looks'!) relatively easy to achieve oneself, or at any rate gives one an uncontrollable urge to make the attempt.

I believe that the majority of people who buy and read this book will not be placid onlookers of art who are content to 'watch from the sidelines' without getting involved in the game. Rather, this book is aimed directly at potential and existing oil painting artists, who want a collection of the best work in the field to inspire them in their own work. To this end I feel that a very important part of the writing of the book lies in my comments on each painting. These needed to be more than just titles and polite discussion. As with *Watercolour Impressionists* I have tried to present not only my own feelings about each work but also what can be learned from each example. The chances are that you won't agree with every statement, but I hope at least that you will be stimulated to delve more deeply into each painting. This in turn will increase your awareness and hopefully improve your painting skills.

In this book I've tried to build up a collection, from around the world, of worthy successors to the original Impressionists. Each painter has had his or her own individual struggle for knowledge before achieving the ease and spontaneity apparent in their work. Apart from the paintings themselves, I've tried to get some insight into their thinking. Obviously, some have been easier than others: many have already written books revealing their innermost beliefs; others have been generous in supplying their work but have been hesitant to talk too much; one said that if he'd been able to fully describe his feelings on his work, he'd be a writer rather than a painter. I hope this mix of painters' work will give you hours of pleasure. For me, just as *Watercolour Impressionists* made me new artist friends around the world, so too had this book, even before it was published.

As you read through the various accounts of the painters in this book, you'll find they don't all use the same methods. Some swear by the *en plein air* method, working on the spot entirely. Some gaze long and hard to take in a mental image of the scene and then turn on their heels to paint back in their studios, fearful that the amount of detail onsite will distract them. Yet others have changed from one method to another as their powers of retention have increased with experience. One can't help but get the feeling that the work of true value is usually a combination of the two methods -- the spontaneous feeling for the scene and the calm consideration away from its distractions.

All the painters in this book would be classed as figurative, even though some verge on the abstract. When I mentioned to a friend that I was following up *Watercolour Impressionists* with one on oil painting, he was slightly apprehensive that there might not be the opportunity for such vivid contrasts of styles as before. Looking through the selection of paintings, however, I'm confident that his worries are unfounded. There is no logical order to the list of artists here, alphabetical or otherwise. My aim has simply been to provide a series of contrasting approaches – peaceful against dramatic, colourful against subtle – to stimulate and excite you. I hope I have succeeded.

Maxwell Wilks

I saw the picture opposite in a magazine called *The Australian Artist*. It had an immediate and instant appeal to me as it is the sort of painting that I myself would hope to achieve – if I ever really painted in oil. It looked so straightforward; but the apparent simplicity and directness of stroke are deceiving, brought about only by years of hard work and experience. Like many of the other artists in this book, running him to earth required a feat of detection from thousands of miles away! I finally tracked him down to Warrandyte, a semi-rural setting about 12 miles from Melbourne in Australia, where he paints and has a studio. I am not surprised to learn that Maxwell's main influences were Monet, Pissaro, Manet and Sisley. Like them he has a strong emotional response to the effects of light, colour, atmosphere, and form. He also paints on-site directly from his subject, which gives his work a fresh and 'immediate' quality.

Now in his late forties, Maxwell Wilks

was trained and worked first in the graphics arts industry, while at the same time studying oil painting with artist Shirley Bourne, who introduced him to the theories of tonal impressionism. This training, combined with his experience of drawing and design, helped to formulate his ideas and style of painting.

Like the original Impressionists, Maxwell became involved with a group of artists who called themselves the Seven Painters and had similar theories to his own. They painted together and gained much from the free exchange of ideas. They even exhibited together for about ten years. It's a situation in which I for one would have loved to have been involved. Since his first one-man exhibition in 1974, he has had 18 others.

For the last twelve years Maxwell has been travelling and working overseas. In 1981 he went to Ireland to paint and held an exhibition of paintings depicting the Irish landscape and way of life. A year later he won the AME Bale Art Travel Scholarship which enabled him to live and paint in England for six months. He stayed in the Cotswolds, a beautiful area in which to work and close enough to commute to London and the galleries. He also travelled to Europe to paint and visit more galleries.

In 1988 Maxwell was invited to lead study tours to France, Holland and England, visiting all the major galleries and painting on location in the English countryside. After each tour he stayed on to paint, and gather enough material for several very successful exhibitions which were held in Melbourne on his return in 1990.

Maxwell feels that painting on location still has the excitement and, even more so, the challenge that studio work lacks. He's always striving to capture a fleeting moment in time, and to achieve this he has had to endure everything from dust storms in South Australia, snow in Victoria, mosquitoes in Venice, and of course rain squalls in Ireland! He says passers-by often think he's crazy. Talking about his way of painting he says:

There's subject matter everywhere, but of course the secret is to know how to select, clarify, and interpret what you see. There are a few important items that you must consider when selecting what to paint: mood, atmosphere and colour of the day; a good balance of lights and darks; interesting structures – both natural and man-made; and activity. After deciding on the subject, the next step is most important – observation. Don't rush in and start, take the time to get to know your subject. Prepare and analyse in your

AUTUMN MORNING, CASTELMAIN ▷
12 x 15in (30 x 38cm)
This is the picture that stopped me in my tracks when I first saw it in The Australian Artist *magazine. It contains the essence of small-town Australia. Its use of light is very much in the same manner as Trevor Chamberlain's (see pages 32-9). There's a lovely sense of depth in this painting, achieved by the use of warm and cool colours.*

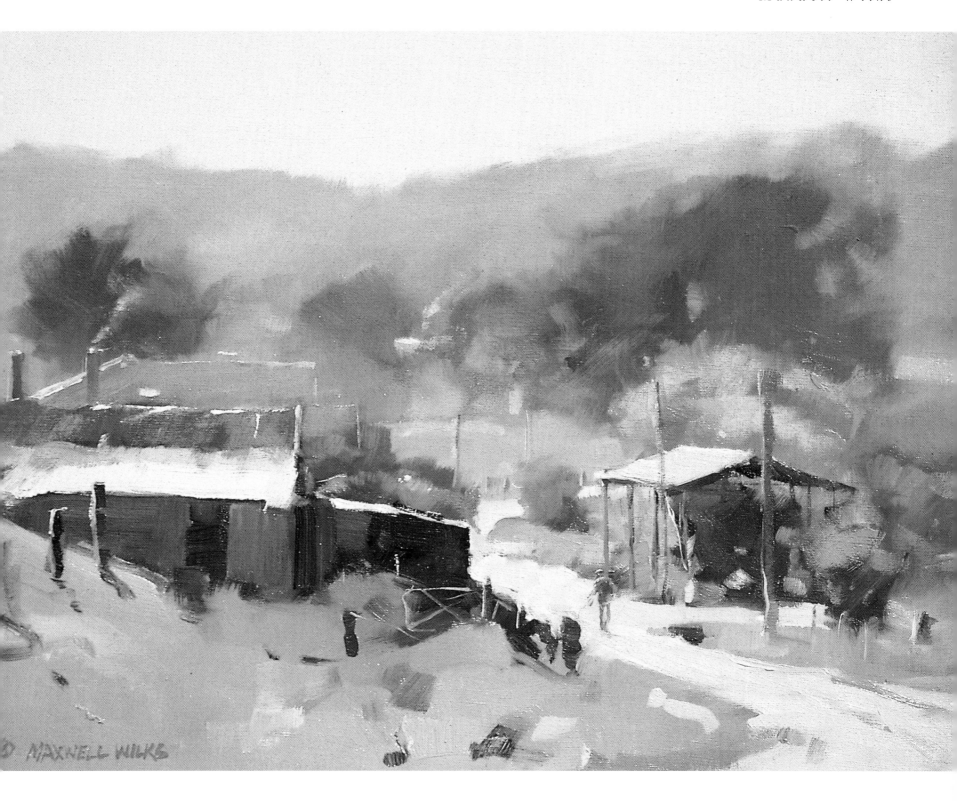

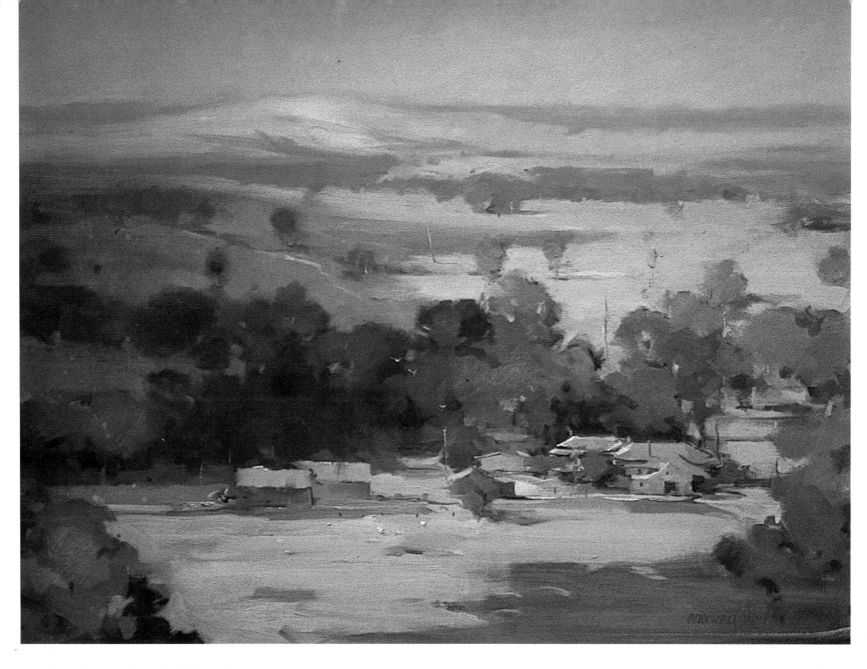

mind then make a decision about why and how you are going to tackle the subject and resolve any problems that you can foresee. Painting is not easy, especially on location. You are at the mercy of nature and to some extent inquisitive individuals who ask such inane questions as 'Are you a painter? What are you painting? How much do you charge?'

and, of course, everyone has an aunt or uncle who paints!

Due to the ever-changing light throughout the day, a subject can change dramatically within minutes, so a certain amount of speed is crucial. Many artists attempt too difficult a subject, use too large a canvas, or paint every last detail. This usually causes

frustration and results in a boring painting. You may be interested to know that some of his paintings take only just over an hour to do. Maxwell manages to paint so quickly because he reduces the subject to a simple set of tonal shapes. Combining this with colour and good draughts-manship conveys a simple statement to the viewer.

◁ SUTTON GRANGE, CENTRAL VICTORIA
There are three distinct layers to this painting. In the front are the warm, rich olive greens surrounding the counterchanged buildings – one can almost feel the heat here. The landscape then recedes to the far distant hills which have been painted in very cool blues.

VICTOR HARBOUR, SOUTH AUSTRALIA ▷
An unusual subject but very satisfying and beautifully balanced. The rails in the foreground take the eye into the picture. The foreground shadows are an important part of the composition. There's lots of lively contrast and colour in the mid-distance and I particularly like the patches of subtle pink and red, next to the gate, which complement the surrounding greens.

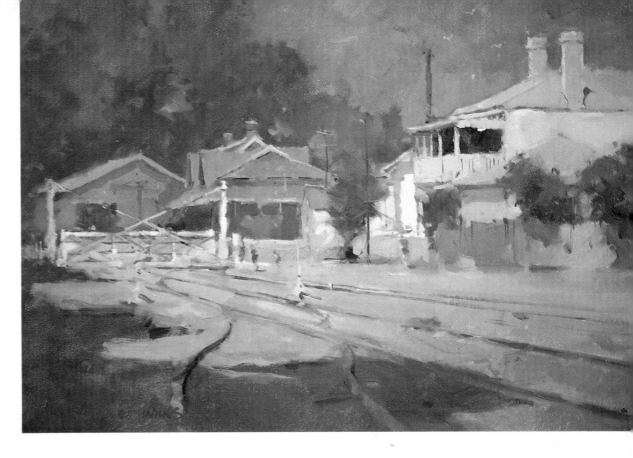

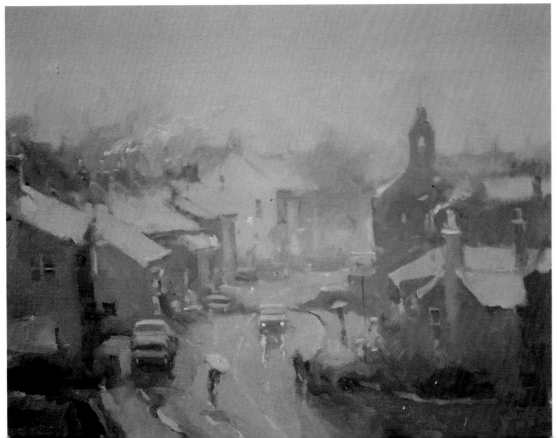

◁ WET DAY, THWAITE, YORKSHIRE
In complete contrast, here we have the gloom and wet of a typical English town. It is obviously late afternoon and the car headlights reflected in the wet road tell the story. The whole painting is composed of warm and cool greys, punctuated by points of light.

13

Maxwell Wilks

EARLY MORNING AT THE DOCKS ▷

In this almost monochrome picture, the only touch of colour is the funnel. The painting is all pattern, values and rectangular shapes which increase in strength as they reach the foreground, where they are counterchanged against the light water.

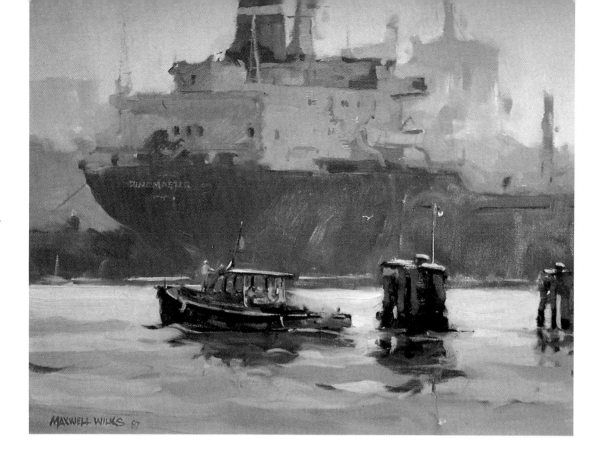

COUNTRYSIDE — TUSCANY,
NEAR CASOLE D'ELSA ▷

This high-key painting is full of dazzling sunshine. Background buildings have been kept deliberately close in value to push them into the distance, whilst the real strength of colour has been saved for the foreground trees, whose warm shadows describe deftly the corrugated surface of the sunlit field.

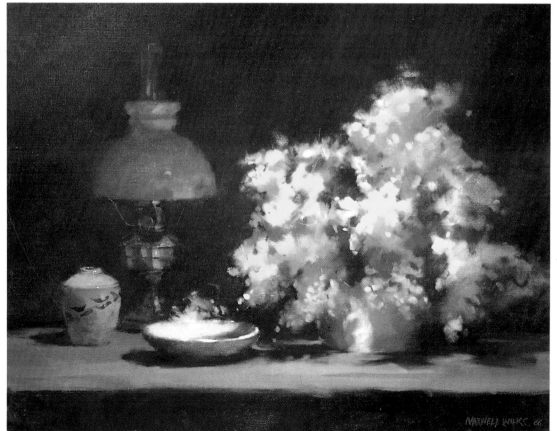

◁ FORSYTHIA

This is a really dramatically lit painting. The main scene is in semi-darkness, and the solitary spotlight is focused on the plate and flowers, creating the maximum effect and contrast.

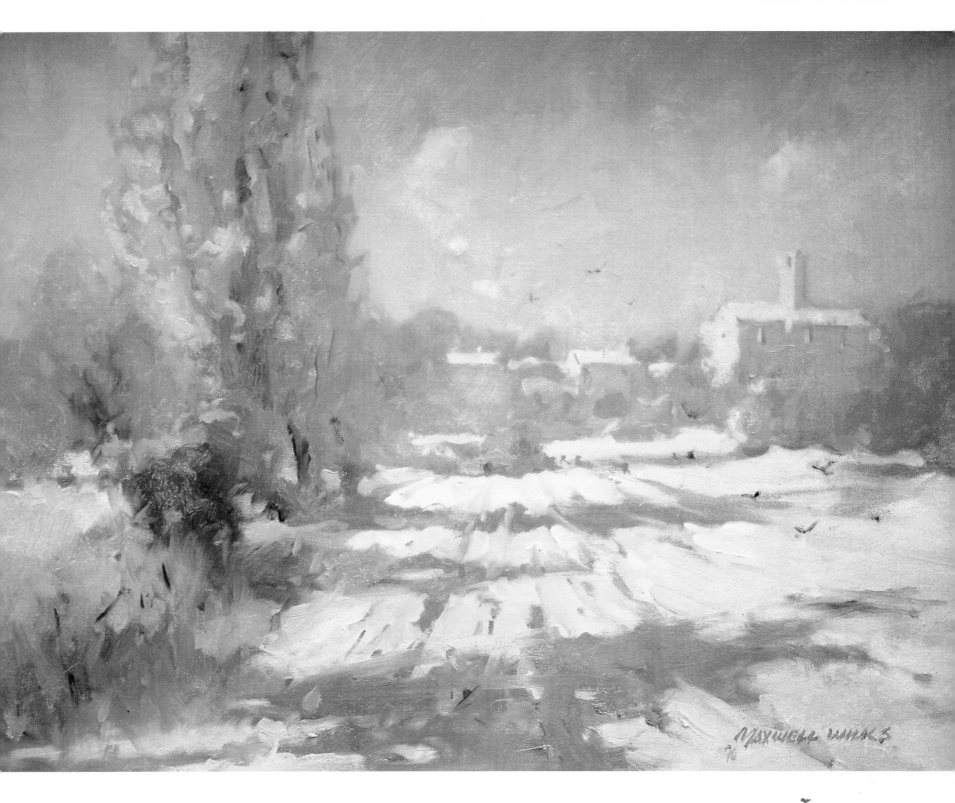

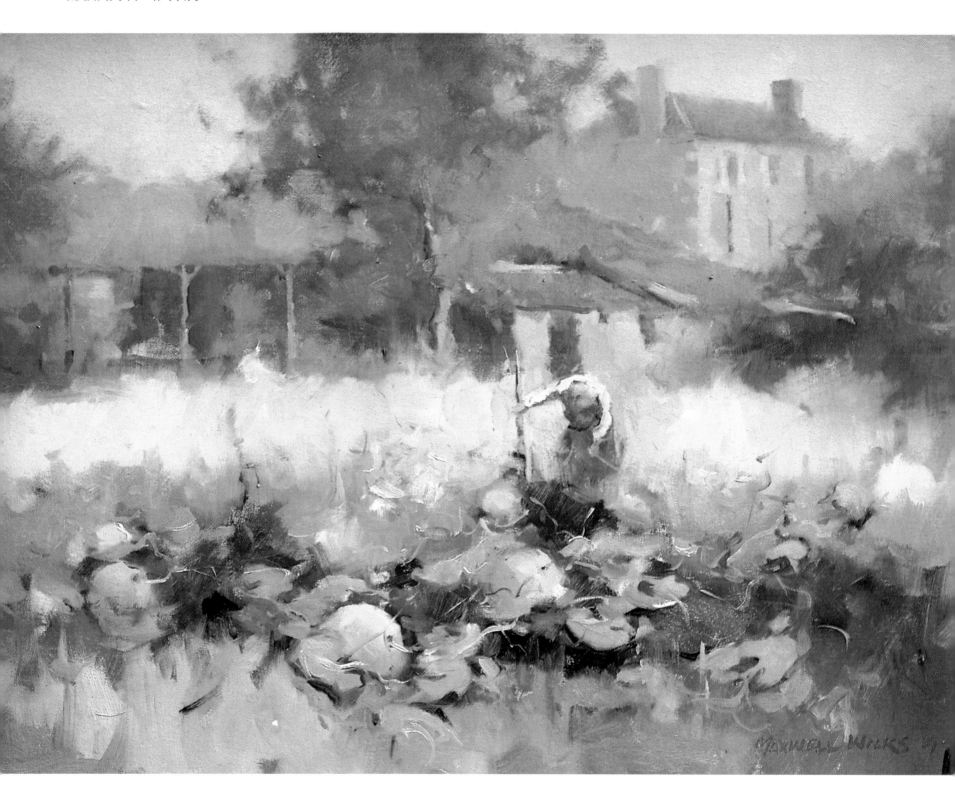

THE GARDENER
This is a typically French picture, with its low-pitched roofs and the old woman bent laboriously over her vegetables. Again, Maxwell has used the misty light to give depth to his painting, the contrasts in the lower half being much stronger than in the top.

△ WET DAY, TORQUAY
Once again the artist has used the device of three receding planes with their respective 'temperatures'. Like the picture of Victor Harbour on page 13, he has used the tiny patch of pink here and there to complement the greens. Unusually, the main activity is confined to the base of the picture, with its strong contrasts.

◁ CARCOUR, NEW SOUTH WALES
Again, this painting portrays typical Australian small-town architecture. The main colours in the painting are greyed down and subdued, so that the main object of interest, the balcony, sings out in strong colour and contrast. Even the foreground tree and fence have been painted with restraint, so that they do not compete with the balcony.

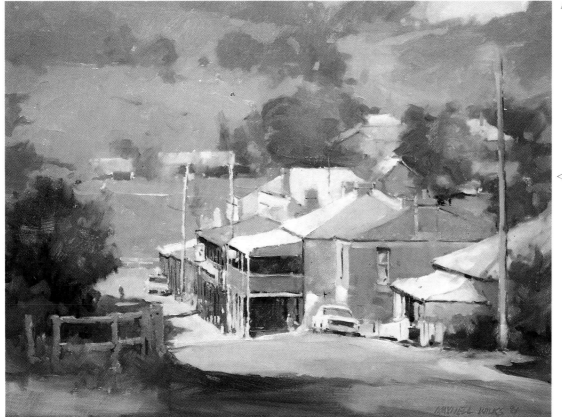

Diana Armfield ARA, RWS

Persuading Diana Armfield to be included in this book has given me the opportunity of showing the work of an enormously respected English painter and also considering what to me is the intriguing situation of two artists, both at the peak of their profession, successfully working and living together as man and wife; Diana is married to Bernard Dunstan RA.

Diana studied at the Slade School of Fine Art and at the Central School of Art in London – an impeccable pedigree! She has taught at the Bryan Shaw School of Art for over 30 years, and her work has been shown regularly at the Royal Academy Summer

Exhibitions since 1965. Diana has also worked as a textile and wallpaper designer. With this background, which includes being a consultant to various prestigious organisations, she might easily have become a formal figure of the establishment. Not so – her paintings are as free as the wind, informal and impressionistic.

Diana and Bernard's time is divided between their studios in Richmond, Surrey and their home in Wales. They also travel and work in France and Italy. Living and working together, it is enormously important that they get their working relationship on a very even keel, and they find that it is absolutely essential for them to have separate rooms to work in. They don't wander in and out of each other's studios much, and Diana doesn't like being interrupted at all. She needs to be lost in a painting for hours and hours, and feels this is the only way she can achieve the necessary rhythm of work, which she hopes is translated into her pictures. They comment on each other's work only when invited, and of the two Diana asks for criticism more. Bernard is inclined to hide his pictures away while he is working on them. They both feel it is essential for them to have a basic sympathy, but not to interfere or try to influence each other's styles. They quoted a painter they once knew whose lady friend gradually took over all his subjects and methods. Her paintings eventually came to look like his, he did less and less, while she did more and more – a situation which I can't ever see happening to Diana and Bernard.

Diana and Bernard both tend to have their own subject areas, which means they don't tread on each other's 'artistic' toes. Bernard's major theme is nude figures in a domestic interior, whereas Diana tends to be more of a landscape artist, painting her figures in cafés, restaurants, and public places. When they go away and paint together in such places as Venice, they also have a tacit agreement, that if one gets involved in a part of Venice such as Florian's café or the Campo Santa Maria Reformosa, the other tends to stay away and find another subject.

When I asked about her approach to painting, Diana said:

> One always works a little bit in relation to the way we are taught at Art School. Not everyone, of course, as some of the 'rebels' react very strongly against the way they are taught, but it suited me. I like the substance of paint, and I like to paint in a way which makes for a beauty of surface, a beauty of touch. The tradition we are both taught in lends itself to an enjoyment of the paint itself.

When I asked about her major influences,

A ROSE FOR HAROLD ▷
11½ x 9in (29 x 23cm)
The cool blue shadows of this painting are very important, as they provide a delicate contrast to the warm pinks and greens of the flowers. There's a delightful freshness and strength in the brushwork too.

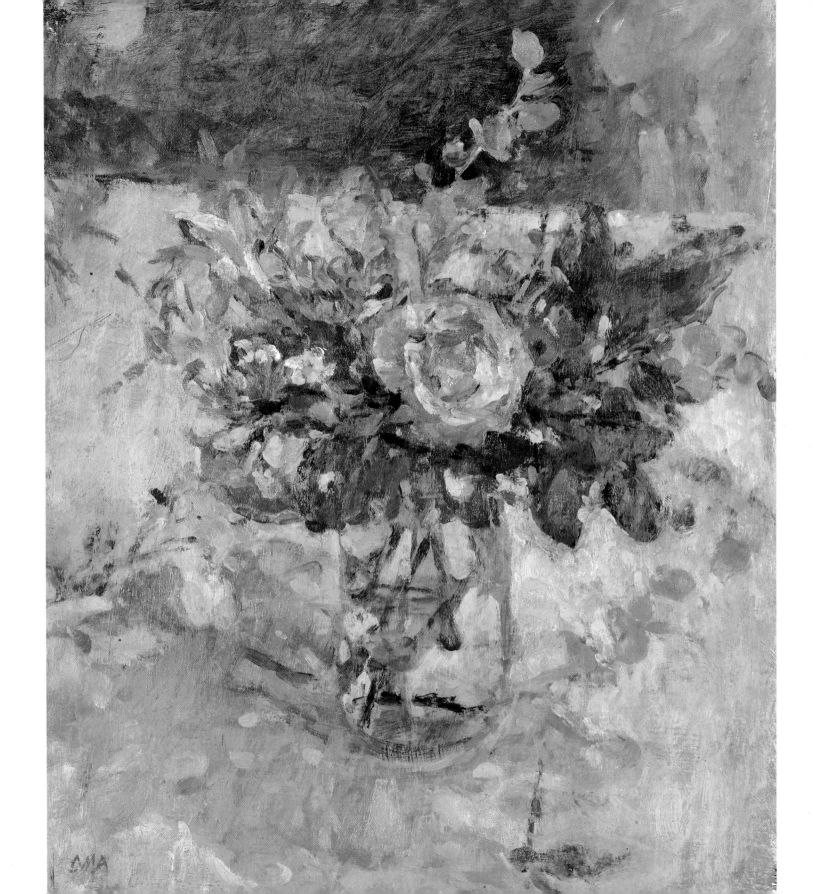

she said she felt she had Sickert and Whistler looking over her shoulder. If she were painting a large landscape she might be thinking of Constable's sketches and perhaps of Cezanne:

I like the feeling that I am drawing fluidly, that every touch is both helping to describe and is also a bit of the abstract life and is therefore in itself pushing and pulling. I often think of other painters while I am working. This is thought to be rather wicked as you're supposed to be being yourself, being original, but I can't say this ever bothered me. If I, accidentally, were painting what looks like Vuillard for instance, I am quite pleased. If I am doing an object drawing, trying to get an arm right, I might think of a Degas pastel and think to myself that he might have made that articulation stronger, for instance.

Although Diana created lots of abstract designs for textures and wallpapers, she has never been tempted to be an abstract painter. Her husband Bernard tried it when he was at art school, but then he went to the Slade and he found the more traditional methods of working suited him best, and he says he never wanted to paint in an abstract way again.

Diana loves flower painting passionately: 'I love them because they demonstrate clearly the subtle rhythms and balance of things, I feel I learn from them in contrast to so much around us that is brutal yet weak – they display grace combined with strength.'

Diana is the very opposite of a 'doom and gloom' painter; she feels one of the things that artists can do, is to show the positive things around us: 'I see no point,' she says, 'in perpetuating in the world a single other thing that is not life-enhancing.' My own feeling, if I may be allowed to say, is that I find a wonderful strength combined with tenderness in Diana Armfield's work. Long may it continue.

All the pictures in this section have been reproduced by permission of Browse and Darby Gallery, London.

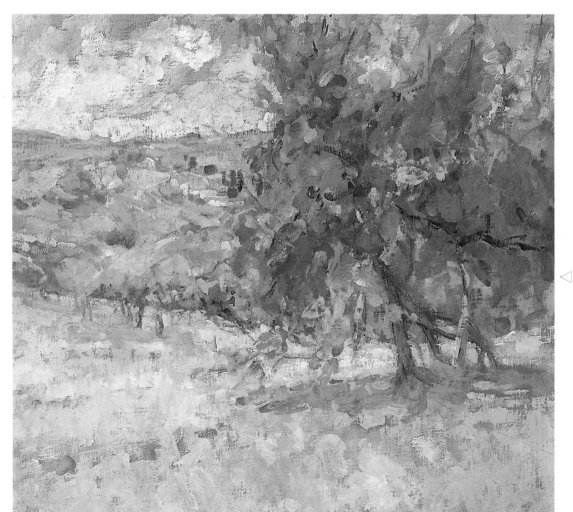

APRIL FLOWERS ON THE SILL, LLWYNHIR ▷
10½ x 8¼in (26.5 x 21cm)
This is such a happy picture; every square inch is simply glowing with subtle colour – there's no monotony anywhere. The bright hues of the flowers are highlighted by the more subdued tints of their surrounding.

◁ SEPTEMBER LANDSCAPE BELOW SAN GIMIGNANO
15¾ x 17in (40 x 43cm)
This painting depicts a beautiful part of the Tuscany countryside I know well. One can almost feel the warmth of the earth in the sunlit foreground. The greens of the foreground trees are rich and glowing, with the colours cooling as they reach the distant horizon.

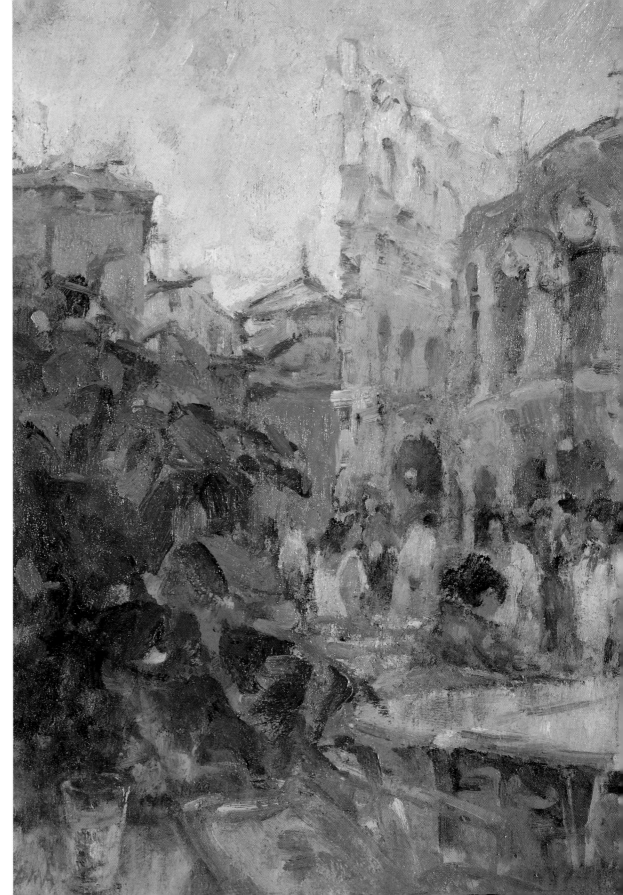

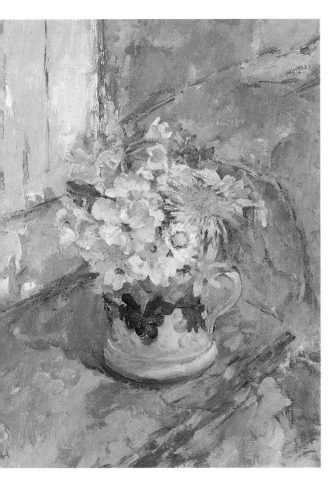

CAFÉ BRA, VERONA ▷
10½ x 7¾in (26.5 x 19.5cm)
This painting is full of life and movement.
There's a subtle change of colour in the
buildings and a lot of animation in the
figures. The picture is given great depth by
the use of strong greens in the foreground
foliage. I was fascinated by the single glass
in the bottom left-hand corner.

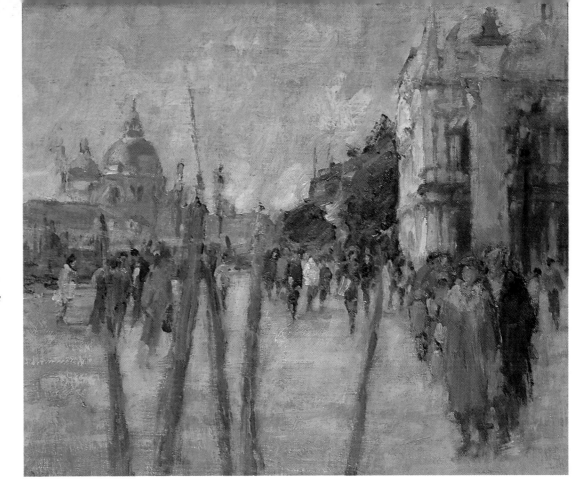

THE KITCHEN GARDEN AT HIGHGROVE IN
APRIL
*This is a symphony of complementary pinks
and greens, alternating throughout the
painting. It is also perfectly balanced in an
informal way. Notice the white of the gate is
counterbalanced by the gleam of white on the
three tree-trunks.*

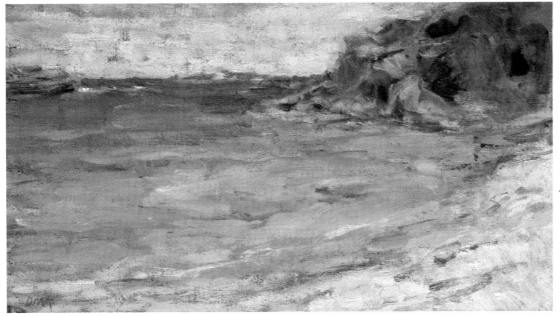

△ VENICE, 'THE MOLO' IN JANUARY
5¼ x 8in (13 x 20cm)
*This is not the normal warm and sunlit
Venice we usually see. It's strictly off-season,
with sparse, warmly clad figures. The
distant Salute is almost a silhouette of subtle
pinks and mauves contrasting with the
solidity of the nearby buildings and trees.
I love, too, the touches of bright colours
amongst the figures.*

◁ THE SHORE, ROLTNEST ISLAND
5½ x 9in (14 x 23cm)
*This painting is like a stained glass window
in its glowing richness and depth of colour.
Diana loves pinks; here she has used them
to great effect in the foreground beach and
sky. The sea colours, too, are exciting in
their variety.*

23

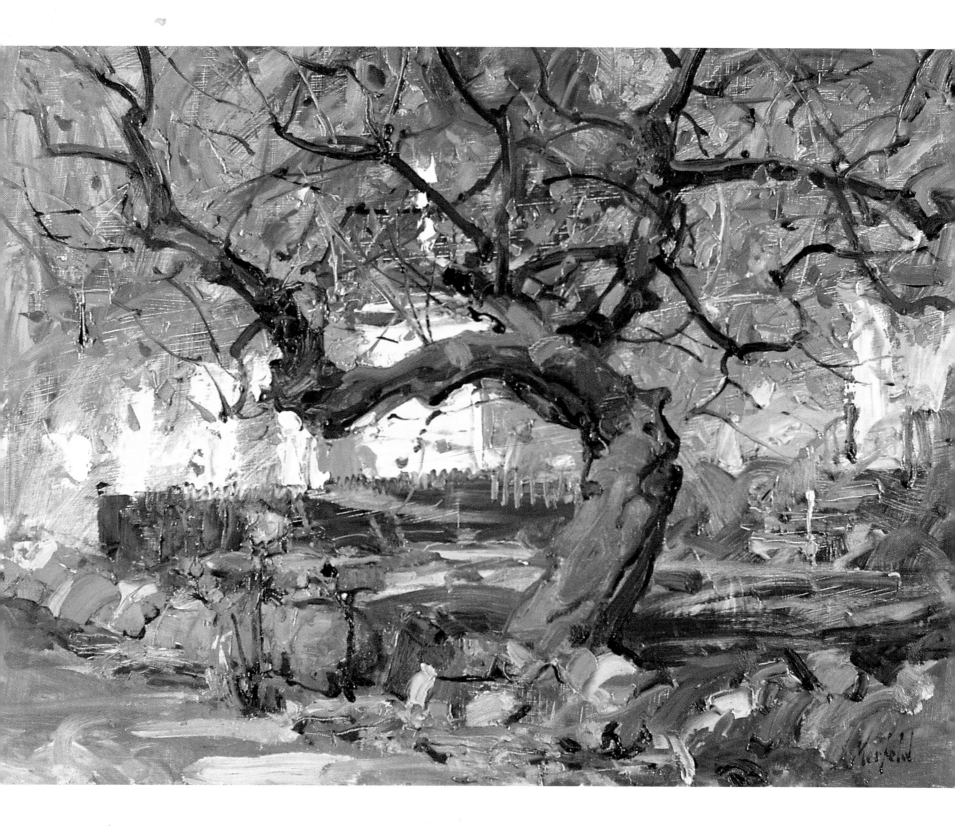

24

Gerald Merfeld

'Contrary to what many people think, Impressionism is much more than using little spots of broken colour.' So says Gerald Merfeld about his type of painting. 'It's catching an image and, through that, reflecting a mood, an emotion, or perhaps a memory.' One has only to glance at the paintings illustrated here to realise that he has succeeded in achieving this aim. One can feel the vitality of his work which, in turn, reflects Gerald's own dynamic personality.

I was immediately attracted to Gerald's work when I saw it in a collection of the National Academy of Western Art, and I felt that this was someone about whom I would like to know more. He lives with his wife and family in a home and studio combination in the country just outside New Lenox in Illinois, which he actually built himself with the aid of his friends. The views from the house, of brook and woodland, are superb and provide on-the-spot subjects for his oil paintings. An old oak tree frames the barn-like structure made of concrete blocks and rough wood. Although he likes to hunt and fish and to see the world, even in his spare time he paints and sculpts. 'I am,' he says, 'fortunate enough to do what I like to do. I want to live until I'm ninety and always keep trying to be better.'

From a child, Gerald was always drawing, and after high school 'got up enough nerve to go to Art School'. He studied at the

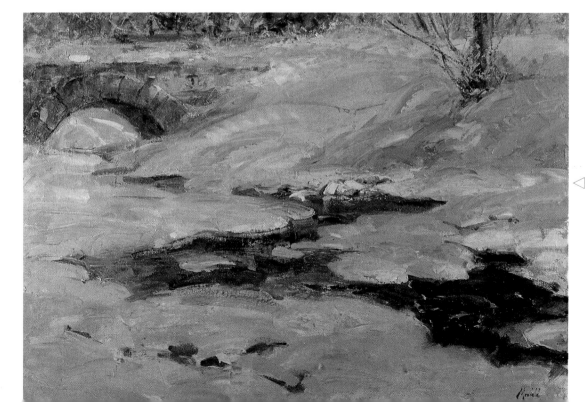

THE OLD TREE
(opposite page)
The most vibrant features of this painting are the incredibly strong brush-strokes combined with rich colour – the bright orange singing against the pure purple. The whole picture is held together by the strong, dark tree trunk. A very exciting painting.

◁ SOLISTICE
30 x 40in (76 x 100cm)
This is a snow scene with a difference, simply glowing with late afternoon sunshine. The snow is not white, but full of exciting colours – mauves, pinks, blues set off by the rich darkness of the stream. Snow scenes have to be well-designed to be successful, and this is a good example of one such painting.

American Academy of Art in Chicago where he specialised in commercial art. However, he soon tired of designing book jackets and drawing cartoons, so he changed to a painting class under William Mosbe. After three years, he was lucky enough to get a three-year apprenticeship with the famous illustrator Dean Cornwall in New York, who was the Norman Rockwell of his day. These years were rich and rewarding. He met many famous artists and had access to the works of great Masters. The bohemian atmosphere of Greenwich Village and constant exposure to various art movements helped shape his individual style as a contemporary impressionist. Another great influence on his development was the time he spent in Vietnam as a combat artist, working as a civilian employee of the US Navy.

Gerald feels that the most satisfying part of painting is not the 'product' but the 'process'; 'it is the discovery,' he says, 'like an athlete, I find the doing is the challenge, and the joy.' He's a real individual and doesn't try to paint like anyone else:

As each artist works, his or her style evolves – it's progressive. Obviously, at school you're first influenced by the instructors, but later, events and ideas produce all sorts of further changes. One's style keeps changing so that painting remains an art and doesn't change into a craft. At the beginning I learned in a very tight style, with lots of anatomy and realism. But after all the discipline you can eventually branch out into freedom.

Gerald prefers to work from sketches rather than from photographs which he feels can become a 'crutch'. He heartily dislikes photorealism, the new movement in which artists paint from enlarged photographs. This, he feels, removes any trace of style or personality from the painting, so that it becomes anonymous.

I find myself agreeing with Betty Harvey who, writing about him in *The American Artist*, said: 'Merfeld is a performer, his dramatic flair is captured in his paintings which seem to suspend the action at the

◁ OWL'S HEAD LIGHT
16 x 24in (40.5 x 61cm)
I can't get over the heat Gerald has managed to get into his colours here. Much of the excitement has been achieved by the strong use of adjacent contrasts, warm against cool, dark against light. In spite of the title of the picture, the real object of interest is the house; don't you love that bright patch of orange below it?

YELLOWSTONE MIST ▷
32 x 48in (81 x 122cm)
What a wonderful sense of wild movement Gerald has achieved in this depiction of water. What I find so exciting is the semi-circle of colour behind the river, ranging from the hot foreground pinks through the mauves to the distant, cool greens. Notice, too, the patch of sunlight on the water.

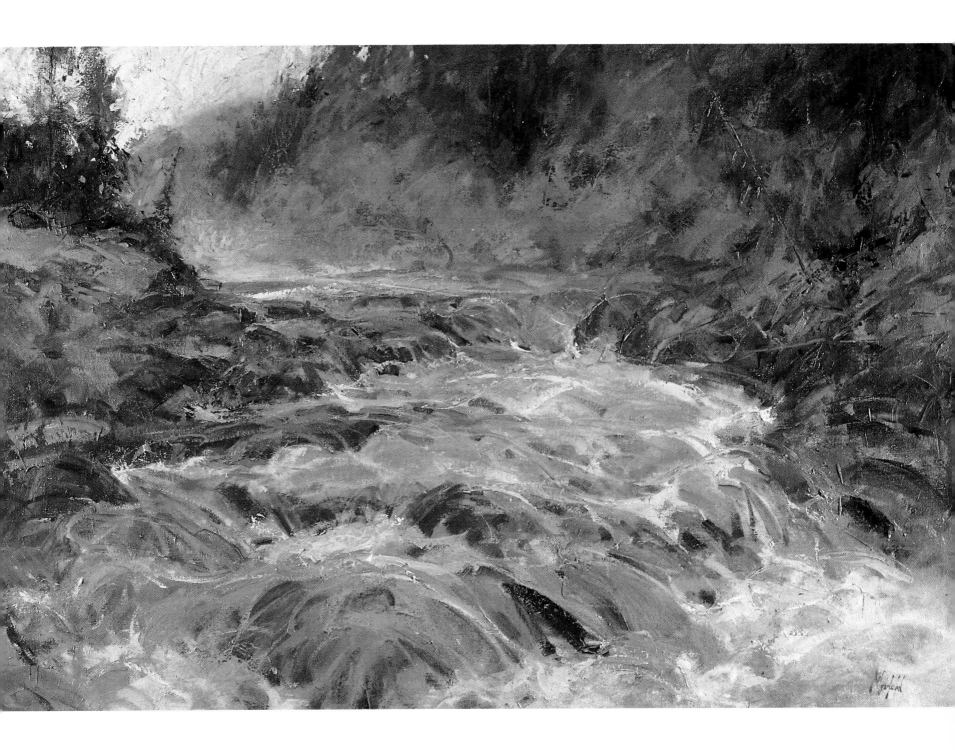

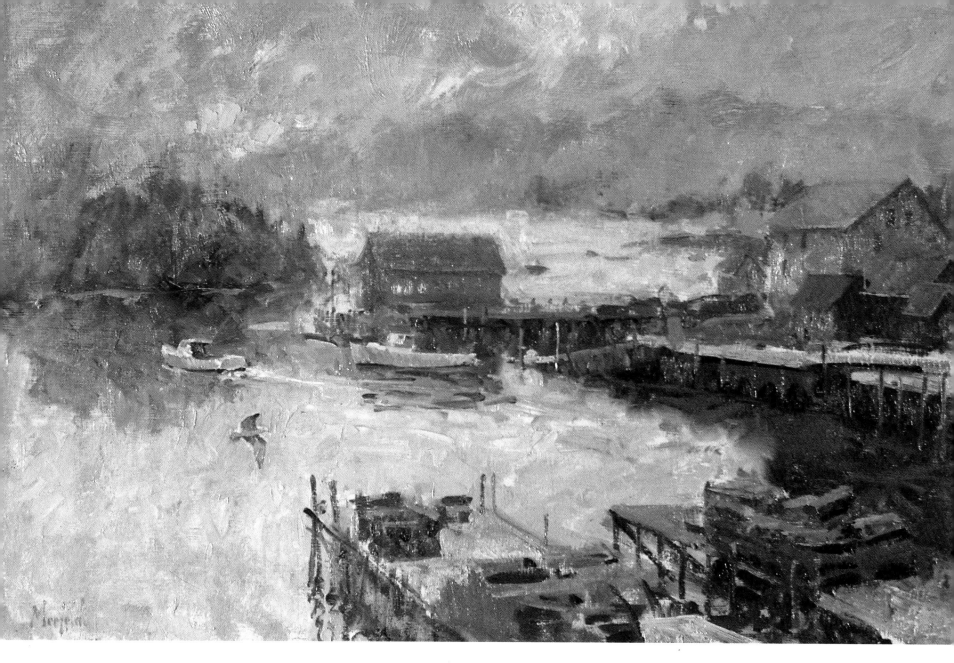

⊿ MISTY

*This calmer, gentler picture could well be the
Maine coast that I know so well. All the
lines seem to lead to the departing boat,
which is contrasted with the dark green
reflections in the water. Compare the subtle,
almost sombre colours here with the wild
richness of that on page 26. The movement
is provided by the strong brushwork.*

peak of the performance and invite the viewer to participate in the drama.'

Gerald's ideas on the wild 'isms' of abstract art are forthright and controversial. Not surprisingly, he's a strong, skilled advocate of representational painting. 'There are so many new and exciting things to be done in this field,' he says. However, the critics and intelligentsia in publishing and museums find 'shock art' more newsworthy. It is also much more difficult to describe changes occurring in the representational art world, and to do so might be construed as admitting that non-objective art (or whatever is in vogue) might be the high road or, God forbid, even the right road! The critics, explaining the latest movement in the art world, wrap their product in key labels, leaving the rest of us to conclude that any fool who works in a representational manner, or those who patronise them, are just misguided unfortunates born 150 years too late. The final put-down is that if you neither work nor patronise their kind of movement, it's obvious that you don't *understand*. They imply that the fact that the painting, the movement or the individual artist needs to be understood or explained makes each more intellectually 'valid' than anything you can merely like or dislike.

There are culture snobs who speak and write in a language of ever-changing 'in', 'hip' and intellectual-type words and phrases (of which one must have a working knowledge!). This serves to keep the general public off-balance and humbled by their ignorance. This, of course, they believe to be important as it helps keep the art world in the hands of the truly brilliant, creative, anointed protectors of artistic purity.

This is all strong stuff, but I for one feel like cheering on the sidelines, otherwise I wouldn't be producing this book!

▽ THE PATH TO GRANDMA'S
24 x 18in (61 x 46cm)
Through the strong, bright sunlight of the foreground fence and foliage, one is tempted into the dim and mysterious woodland through which the three children are emerging. Look especially at the rich, subtle blue-green of the distant trees.

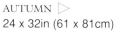

THE LONER
36 x 30in (91 x 76cm)
Gerald has used every trick in the book to give the impression of warmth and excitement, such as the use of complementary orange against mauve, combined with an extremely strong sense of design.

ASTERS ▷
Gerald has made great use of counterchange here, placing light flowers against dark foliage. The brush-work is vigorous and the colours vibrant. The positioning of the fern and flower on the table helps to balance the picture. I love that strong purple in the top corner.

AUTUMN ▷
24 x 32in (61 x 81cm)
This is a picture which tells a story. It's pumpkin picking time, and here the children choose their pumpkins for Halloween, watched over by Dad. There's a lovely patch of warm, rich colour in the middle distance, behind which the house is portrayed in subtle mauve-greys. It's a painting full of life and movement.

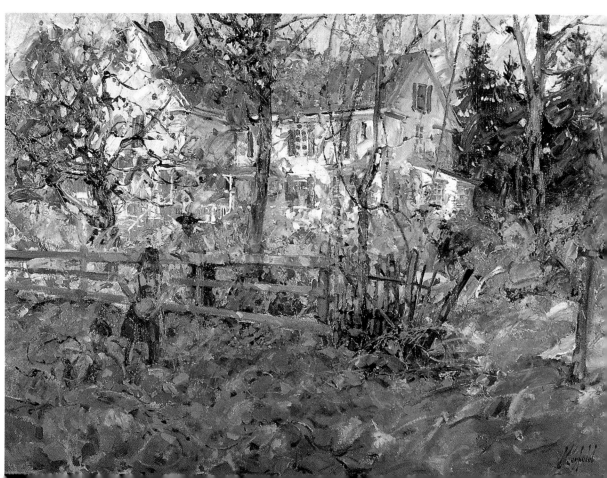

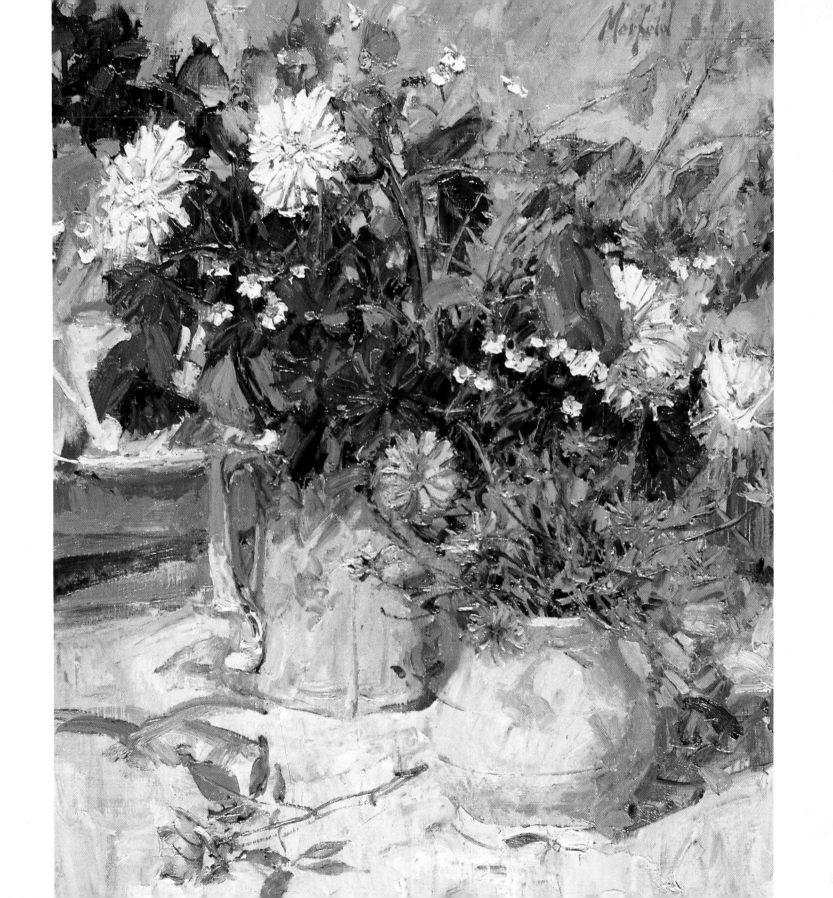

Trevor Chamberlain ROI, RSMA

Trevor is an artist whose work I have admired for many years. In fact seven years ago, when my publishers asked me to produce an instructional book on oil painting, he was the first person I thought of. We had soon agreed to work together – Trevor would provide the illustrations and I would write the text, sitting at his elbow as it were. However, this was only a beginning! Because his watercolours too were outstanding, when I later wrote *Watercolour Impressionists* it was inevitable that his work would be included.

At first glance, Trevor's work appears almost traditional, with none of the bravado and showy technique which characterises the work of some of my other favourite artists in this book. Trevor uses his skills unobtrusively, always allowing the subject matter itself to be of prime importance. However, he is a true impressionist, preferring to work out in the open air in all weathers to capture that quality of freshness, excitement and directness that is so characteristic of his work (in the past I have even held an umbrella over him in squally rain while he worked doggedly on). In really bad weather he has a method of working in oils from the front seat of his car – but more of this later.

Completely self-taught, it wasn't until 1964 that he abandoned his work as an architectural draughtsman to become a full time artist. Since then his work has been universally recognised and respected throughout his profession. His list of

SUMMER BY THE THAMES AT RICHMOND ▷
14 x 20in (35.5 x 51cm)
This painting is all about light and shade – the line of moored boats bathes in full sunshine while the foreground figures are shaded by the trees. Many of Trevor's pictures are inspired by this interesting interplay, which he often considers more important than the actual subject itself.

SHADY MOORING
(opposite page)
I was completely captivated by the quality of light in this exciting painting, and I knew immediately it had to be this book's front cover picture, typifying all that I most admire about modern Impressionism.

32

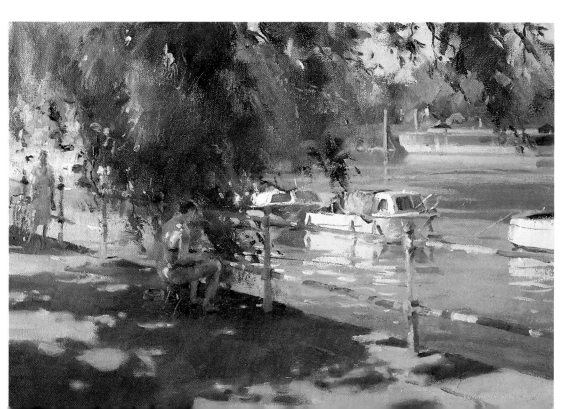

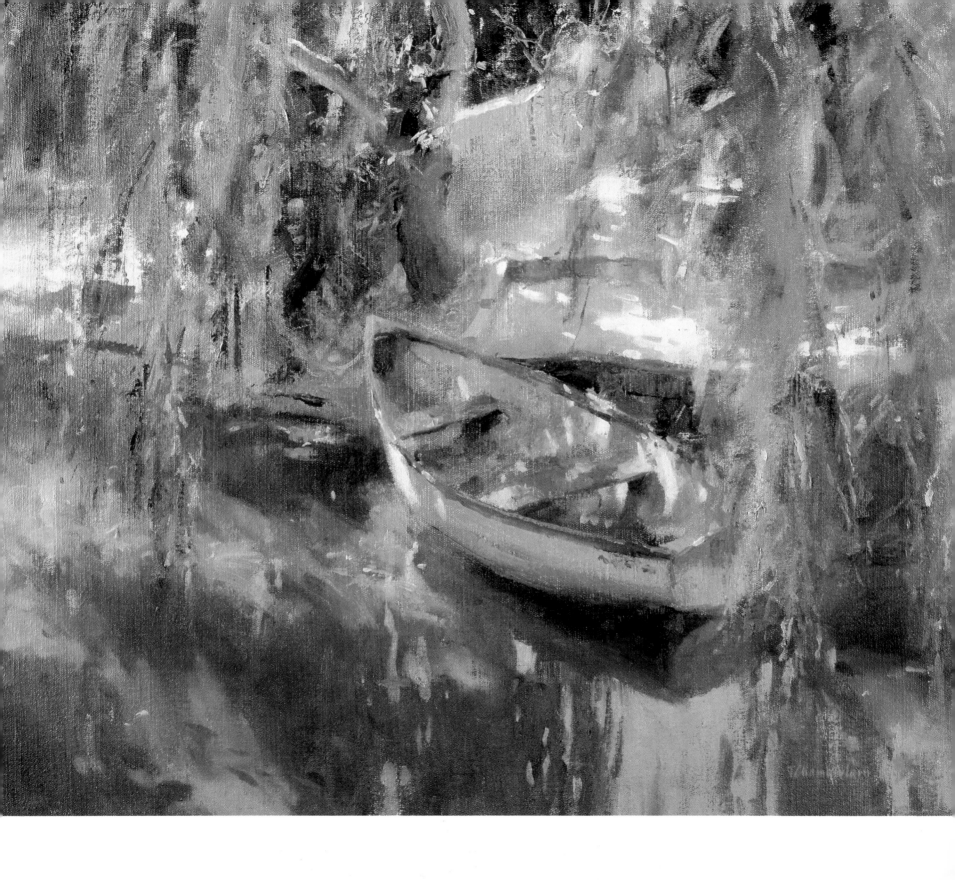

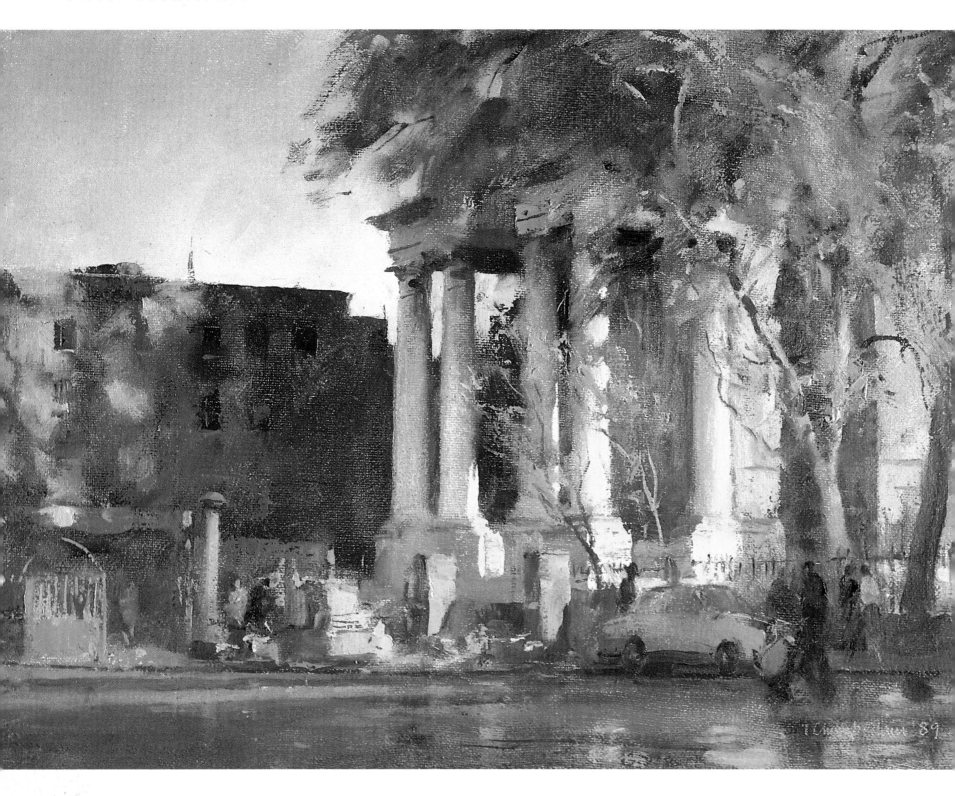

achievements and awards is long and impressive, including membership of the Royal Institute of Oil Painters, the Royal Society of Marine Artists and the famous Wapping Group, as well as being President of Chelsea Arts Society. What makes him so outstanding for me, however, is that he paints in an exciting style which thousands of would-be oil painters would love to be able to emulate.

Now to his materials. Whilst many of us get trapped into buying all sorts of unnecessary gadgets, thinking they're going to solve all our problems, Trevor, working mainly in the open, has reduced his equipment to the bare essentials. He restricts his main colours to eight, which are: titanium white, yellow ochre, cadmium orange, light red, veridian green, cobalt, ultramarine and burnt umber. He occasionally makes use of small quantities of cadmium yellow, crimson, cadmium red and sap green. He avoids the rather bewildering range of liquid mediums and oils available, instead relying wholly on a tube of Rowney Gel Medium to mix with his oil colours. This he squeezes out on to the palette like another colour, first mixing it with white and leaving another blob to add to his subsequent colour mixes. He says it halves the normal drying time of paints.

He uses one knife only, both for mixing his paint and applying it to the canvas, scorning the use of specialised painting knives with little trowel shapes as being too fiddly, softening off the knife strokes occasionally with a judicious finger. His brushes, too, are kept to a minimum. First a large No. 10 flat, long haired bristle for preliminary blocking and painting, size 3, 5 and 7 bristle brush for general painting, finally a fine sable rigger for details.

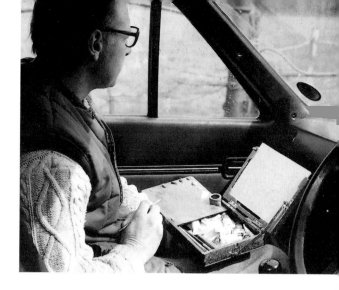

Trevor's tiny pochade box enables him to produce paintings in bad weather conditions and difficult cramped circumstances. Here he is using it in the front of his car.

◁ SPITALFIELDS, LONDON
10 x 14in (25 x 35.5cm)
The dark building in the background is deliberately used to highlight the beautiful sunlit columns, the verticals being repeated by the trunks of the trees. There's also a lot going on in the foreground, which you don't at first notice – such as the dark figures, and what could be roadworks, and also the gentle reflections in the wet street.

MIST CLEARING, TENBY HARBOUR ▷
10 x 14in (25 x 35.5cm)
This is a very strong design with plenty of depth. I know this tiny Welsh harbour well, and Trevor has captured the ambience of the place. The colours here are deliberately subdued, but the tones have been used to great effect. There is a classical simplicity about it all.

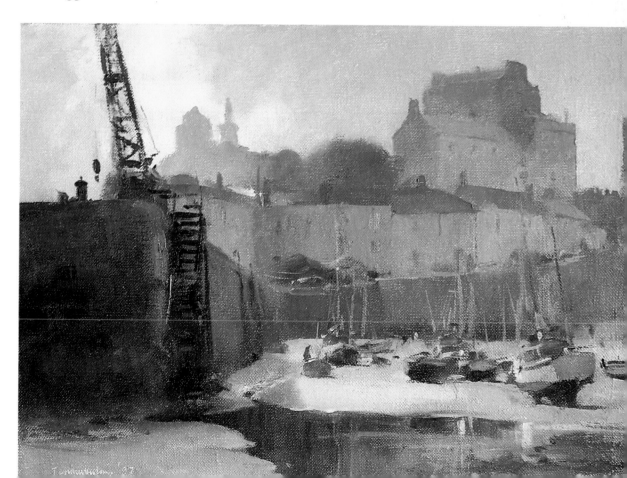

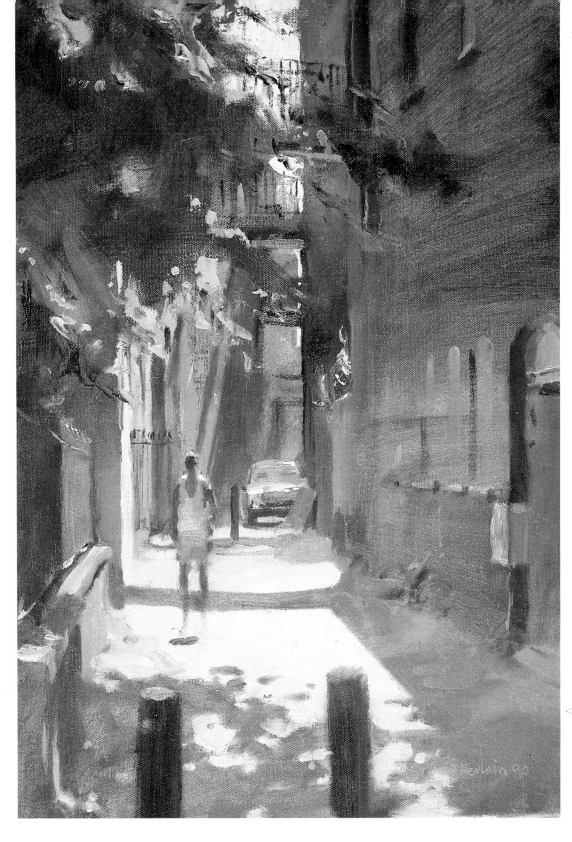

A unique and very important part of Trevor's equipment is his pochade box, actually a small nineteenth-century device. The box measures only about 9x7x3in (25x20x7cm) which not only holds brushes, palette knife, etc but also, when open, holds three 6x8in (15x20cm) boards at a suitable angle for painting. The boards are kept separate, which avoids accidental smudging of the wet surfaces. The advantages are obvious. It's compact, portable, very un-obtrusive and doesn't require an easel. Thus Trevor can paint in quite busy locations without attracting too much attention. He can use it sitting or standing, or tucked away in a confined corner. It is especially useful for such situations as busy street scenes, or church or station interiors. In a car, though, it really comes into its own. Trevor has found this invaluable, enabling him to paint in comfort regardless of wind or weather. Paintings produced in this way stand comparison with larger works and many are shown in this book.

Trevor believes fervently that to convey subtle feelings of mood, atmosphere, light, tone and colour convincingly one must work on the spot, even if it means becoming cold and wet in the process. Not for him the quick, furtive sketch through a car window and then a dash back to the studio to try to recall the transient feelings and subtleties of the moment. Having selected his subject, he works in one sitting for a maximum of three

◁ SUMMER HEAT, ROTHERHITHE
The effects of bounced light in the shadows are obviously what attracted Trevor to this scene, which in itself is not an obviously picturesque subject. However, he has endowed it with vitality and warmth, which is immediately obvious to the viewer.

hours, working with enormous concentration to make an immediate statement. He then goes back to the studio to do another hour's work, carefully criticising his work and making refinements. He does not believe in going back another day as, because of changing light and different circumstances, no two days are ever the same.

Trevor is inspired and obsessed by the effect of light; this is a constant theme which runs through his work. He will often be drawn to a scene by the play of light, not the actual subject itself which to the rest of us may look almost mundane. I once asked him why he chose to paint the interior of a London bus garage, and he said it was the play of light on the diesel fumes that excited him!

▽ DAWN FROST
10 x 14in (25 x 35.5cm)
One can almost feel the sharp nip in the air just by looking at this tranquil painting. I love Trevor's use of pinks and mauves, normally warm colours yet used here to give an effect of cold morning. The vertical element of the church tower is placed exactly right.

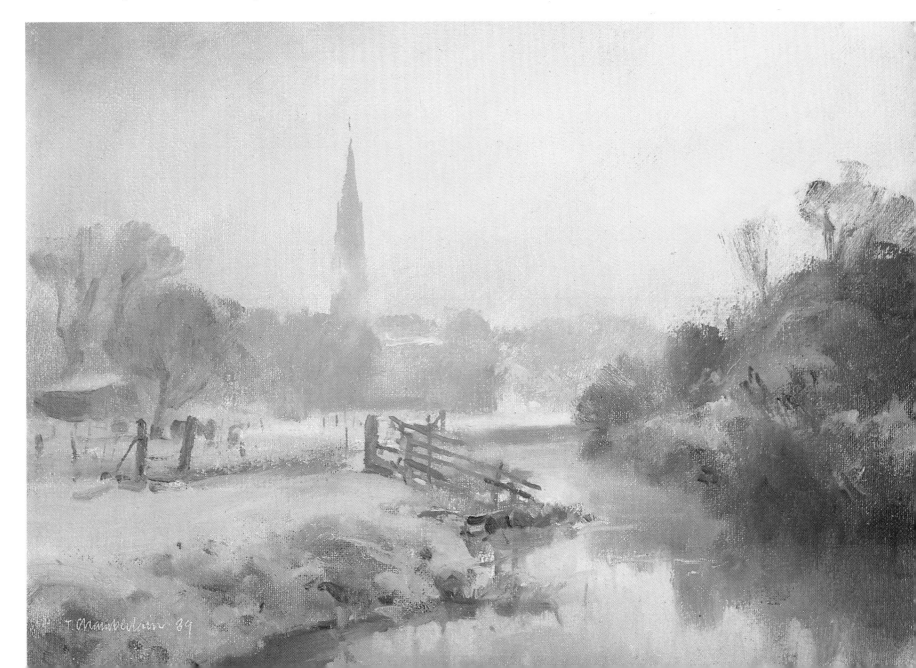

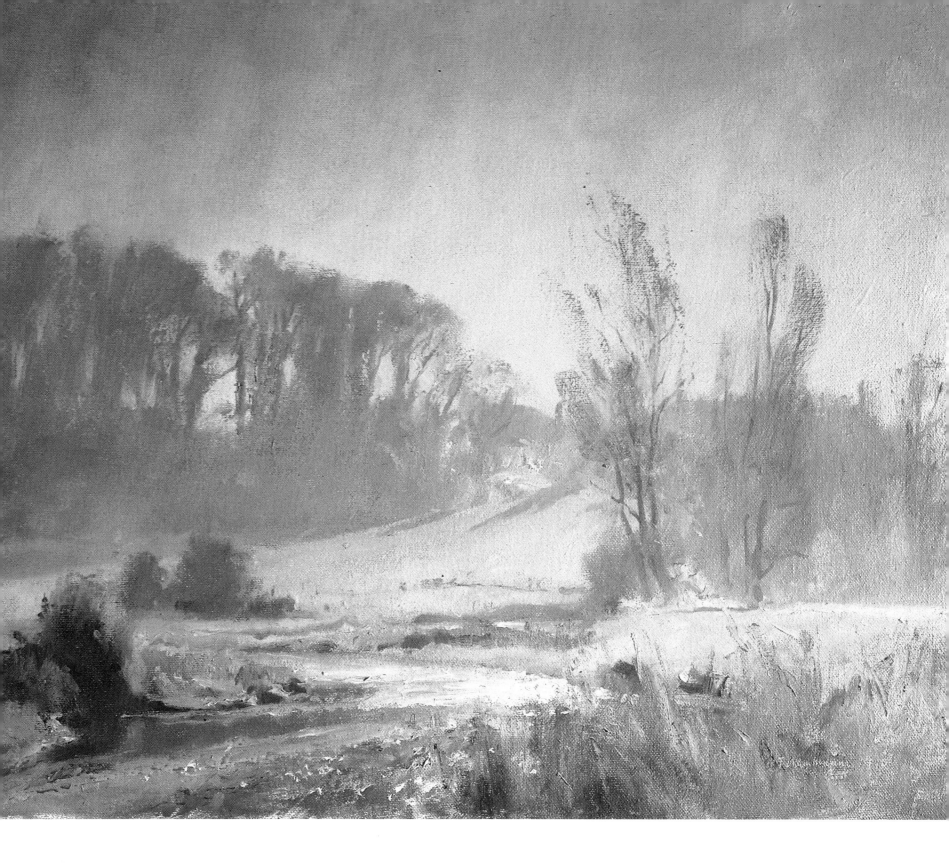

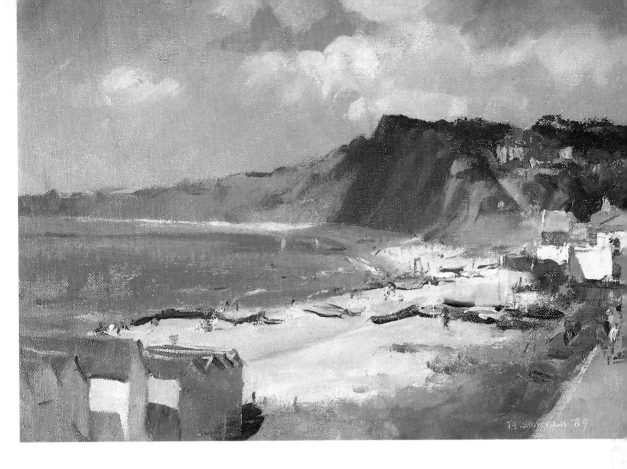

WINTER MORNING, RIVER MIMRAM
16 x 20in (40.5 x 51cm)
Trevor has achieved the misty effect by keeping the distant trees to flat, cool tones and gradually strengthening and warming each layer until it reaches the rich dark foreground bushes. The sparkle on the water is very effective, particularly as the river rounds the bend, where it becomes the focal point of the whole painting.

△ **SUMMER MORNING, BUDLEIGH SALTERTON**
10 x 14in (25 x 35.5cm)
Trevor's love of light is evident here. One of the most exciting aspects of the painting is the way he has put a strong cloud shadow over the sea and cliff, with sunlight each side of it. This dark shape is balanced by the huts in the left foreground.

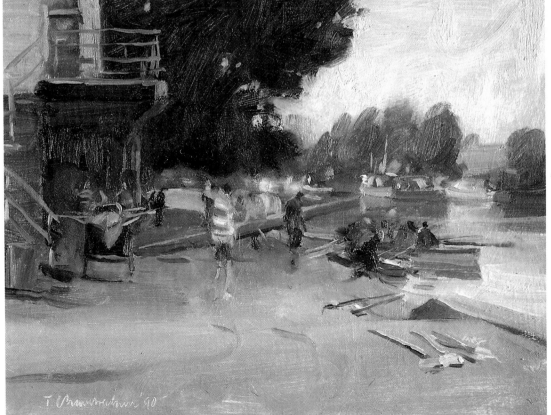

◁ **ROWING CLUB, RIVER LEIGH, CLAPTON**
6 x 8in (15 x 20cm)
Judging by the size of the original, this is obviously a painting done with Trevor's pochade box. He has kept all the activity to one portion of the picture, leaving the fore-ground relatively plain as a foil to it all. The painting has a very strong overall pattern, the focal point being the striped sweater on the standing figure.

Don Stone ANA, AWS, DF

I teach watercolour in the little village of Port Clyde on the US coast of Maine every summer. It's a lovely, unspoiled area where the main industry is lobster fishing. On my day off I catch the little ferry boat at 7am to the tiny magical island of Monhegan. Once there, I walk the paths (there are no roads) visiting the various artists' studios, drinking innumerable cups of coffee and talking shop. Many of them are famous, like Jamie Wyeth or Lawrence Goldsmith. It's an expensive day for me, because I hardly ever leave without buying a painting. On my memorable first visit there I met Don Stone on a path. He asked me into his studio to sign one of my books, and I spent hours there admiring his superb work. The result was that he was one of the artists in *Watercolour Impressionists*. The tiny, loose watercolour sketches I used were, in reality, studies for his larger paintings in oils or egg tempera.

One very interesting item in his studio was a television screen standing by his easel, with a mysterious black box beneath it. He showed me how it all worked; he uses his normal video camera to record such local things as breaking waves on the rocks or wildly tossing boats. Back in the studio the 'magic box' is able to stop motion, move forward frame by frame, intensify the image, or even give a negative image. It's hugely exciting to play with and it gives one a great deal of information. Once you start painting, though, you're still on your own. However, the masses of bulging sketch books I found everywhere revealed that he still relies almost entirely on these for his composition and creative preparation.

Don also described to me some of his personal oil painting methods. Once he's selected his subject matter he begins by making several small black and white thumbnail studies (about 3x5in/7x13cm). At this point he concerns himself only with the abstract, and using absolutely no detail he works out the larger, simple shapes with only two or three well-separated values. These are usually followed by the watercolour studies I mentioned earlier.

Don paints his oils on canvas which has been single-primed with white lead. He then stains the canvas with ivory black of a medium to light value. Thus when he lays down his first statements, they are registered against a middle value, rather than the stark white of the canvas. This gives him an idea of their truer relationship to their neighbouring colours and values.

He begins by blocking in with Mars violet, the darks first, and working up to the lights, but at no time in the early stages of the painting does he use white. To get lighter values on the canvas he simply uses turpentine to lift the colour off. Incidentally, in the early stages of the paintings he works very thinly – almost a watercolour-type effect. Only in the later stages does he use any medium and then he only uses a mixture of five parts turpentine with one part stand oil. Oil paints today can be used almost as they come out of the tube, so he uses the medium very sparingly. He tries in the early stages to achieve a good, strong contrast, somewhat like an over-exposed photograph.

Then comes a very interesting technique, which gives his paintings a really strong glow. He works in what could be called a reverse colour scheme. In other words he begins by laying down the reverse or complementary colour. This complementary colour must always be warmer than the colour which covers it. If, for example, the sky is blue, he paints it orange; or if it's violet, he first lays in yellow. Likewise if the sea is green, he paints it red. All the while,

OFF NORTON'S LEDGE ▷
10 x 14in (25 x 35.5cm)
Here we have a good example of how Don uses complementary colours, in this case orange under the sea colour, which gives a vibrancy to the finished result. The boat is a typical local lobster boat working off Monhegan Island. Notice how effective the patch of sunlight is around its prow.

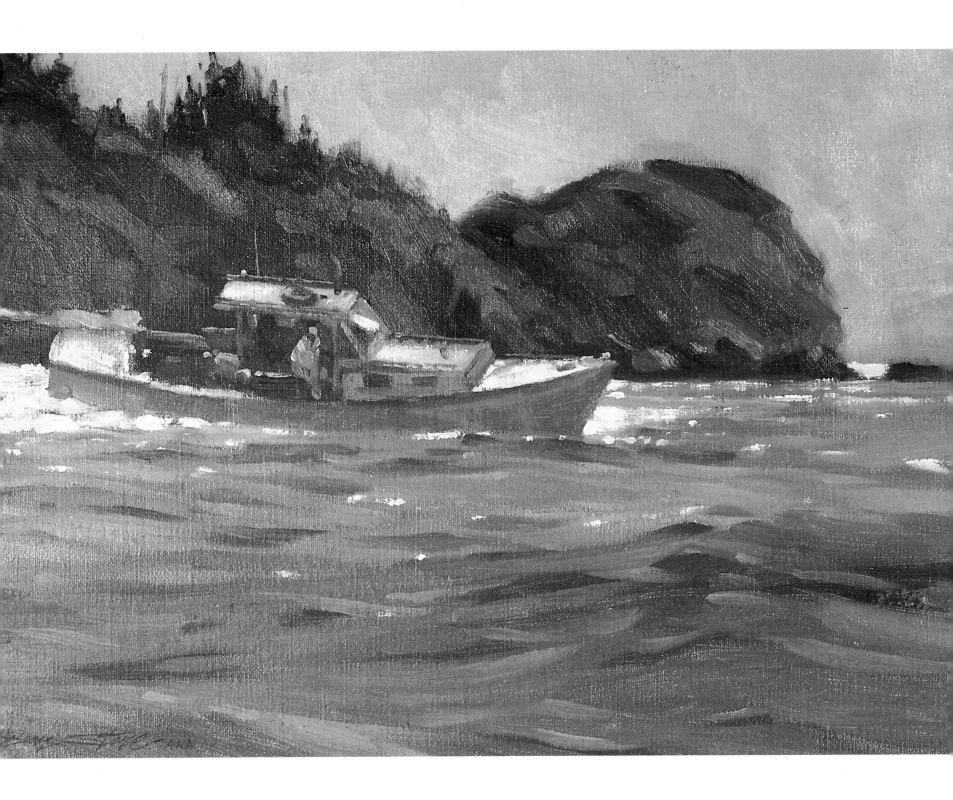

he is still concentrating on establishing the correct value relationships.

Once he has the entire canvas covered with the complementary colour he begins the overpainting. This time he begins with the sky – now using some white. He is very careful when registering the value for the sky, as this will set the mood for the rest of the painting. However, he feels that one must be very careful of white because as he says, 'it's the ruination of many good oil paintings'. He then carefully establishes the final colours for the rest of the painting, painting over the complementary colours and, importantly, allowing some of the under colour to come through, creating the vibration which he feels gives a painting so much more excitement. At the same time he adjusts the values of the final colours, striving to keep them as close as possible to those established in the beginning. He tries to keep

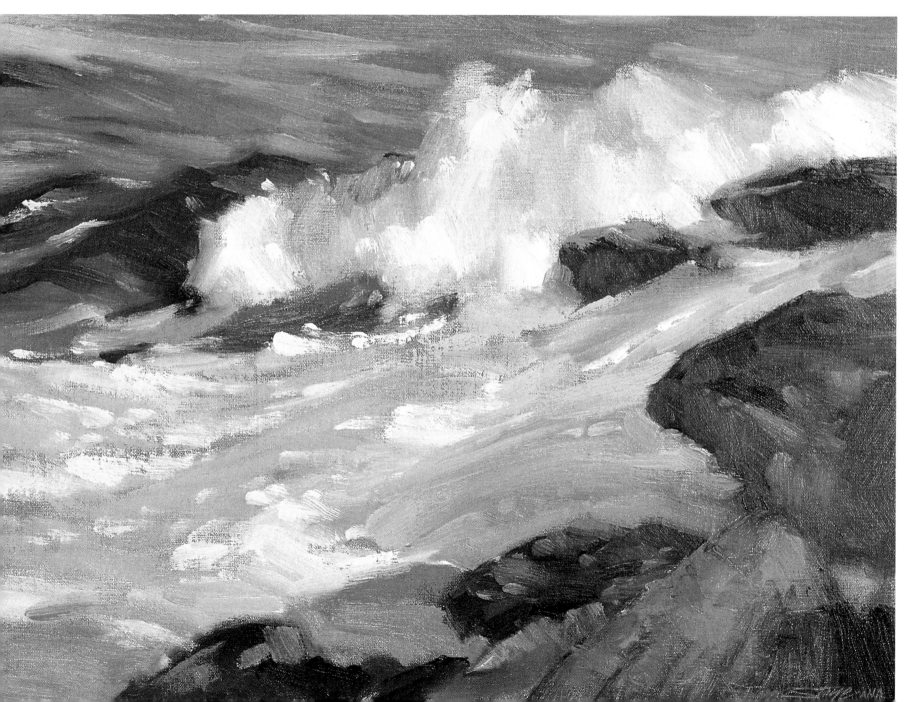

most of his darks transparent, but the sunlit colours he paints heavily, loaded with paint. He feels sunlit areas should have texture, colour and detail.

In all his paintings Don begins with a few large, simple shapes and strong contrasts, keeping it as simple as he can, for as long as he can. Only at the end does he add the few details he finds necessary, concentrating almost entirely on shapes – not things. Don's work has received national acclaim. He's an Associate Member of the National Academy of Design and a Full Member of the American Watercolour Society. He has won more than 65 major awards, including eight gold medals, and his paintings have been bought for museums and private collections all over the world. I've learned much from this man and look forward, on my next visit, to meeting him again.

FURLING THE SAILS ▷
10 x 8in (25 x 20cm)
A really unusual subject, but I wouldn't like to be stuck up on the bowsprit myself! However, it has given Don an ideal opportunity to express the movement and subtle colour of the sails. The precariously balanced figures make a good contrast to them.

◁ AFTERNOON SEAS
10 x 14in (25 x 35.5cm)
There's a strong element of design in this painting, combined with vibrating colours. Notice again the underglow of orange showing through in places. The variety of brush-strokes themselves emphasise the static quality of the rocks in contrast to the fluidity of the sea.

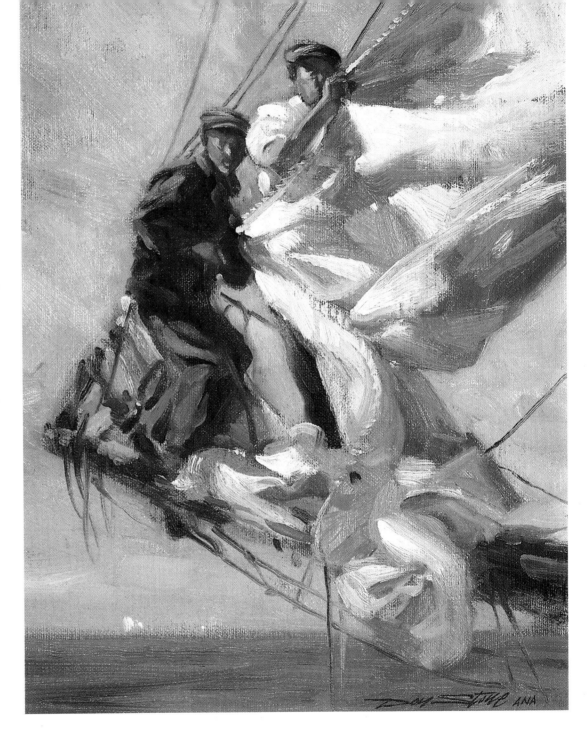

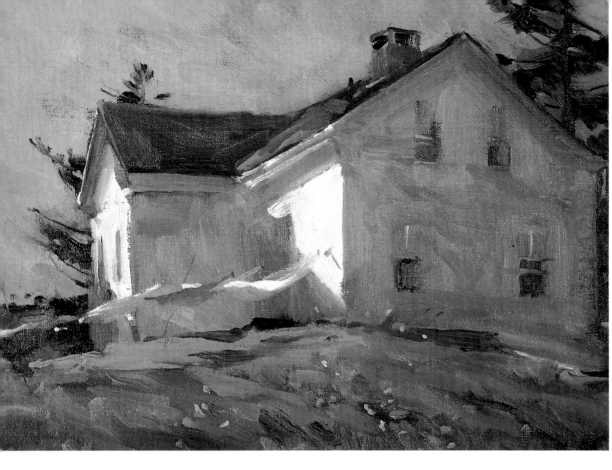

STUDY FOR NETMENDERS ▷
12 x 16in (30 x 40.5cm)
The restricted palette based around the mauves has given this picture great unity and clarity. I love the effect achieved by counterbalancing the curve of the boat with the opposing curve of the sheltering sail.

▽ MORNING FLIGHT
16 x 24in (40.5 x 61cm)
The pattern of the waves against the dark sea gives this picture strength and unity, the calm sky contrasting with the turbulent sea below. The birds, ranged above the surface of the sea, give added interest and movement.

△ WASH DAY, MONHEGAN
10 x 14in (25 x 35.5cm)
The warmth and colour in the shadows help to make this a memorable painting. The movement of the brush strokes on the ground cleverly echoes the wind-blown washing on the line and the patch of sunshine on the wall brings the picture to life.

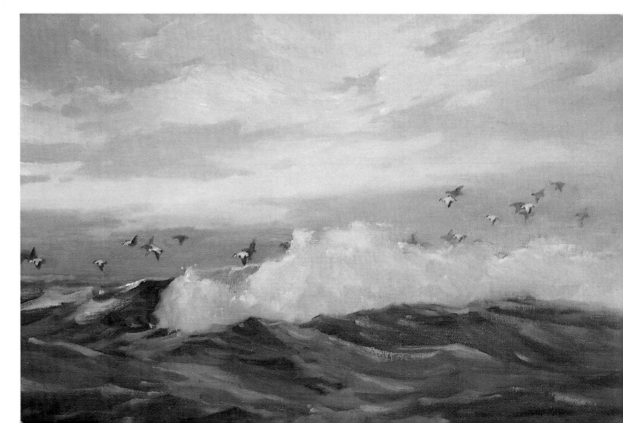

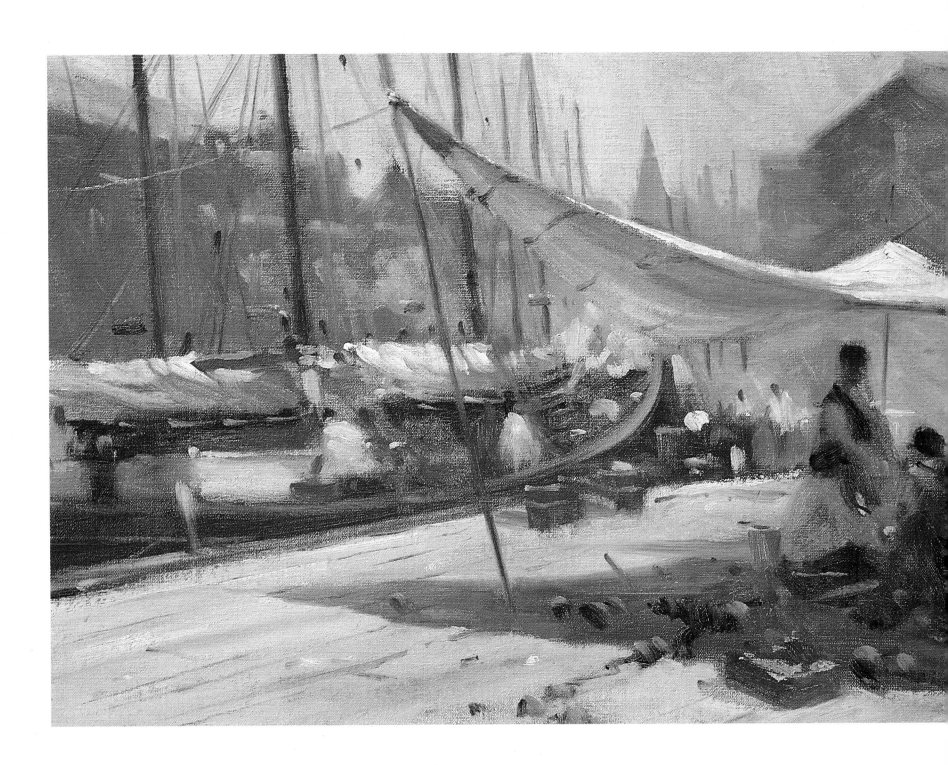

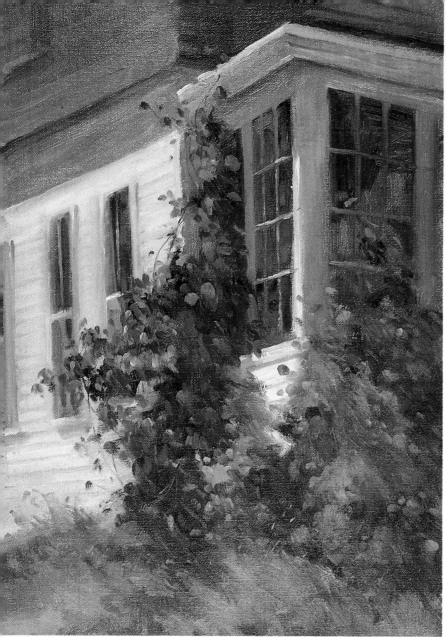

◁ CLEMATIS
14 x 10in (35.5 x 25cm)
This charming painting depicts a typical Monhegan Island house, the white clapboarding providing an excellent contrasting background to the rich colour of the flowering plants. The flowers have been indicated with great restraint and sensitivity.

▽ THE PATH TO THE SEA
Another Monhegan subject. The trees and distant sea immediately attract attention by the use of lightest light against darkest dark – a classical formula used here to great effect. The foreground has been made interesting by the use of adjacent, complementary colours.

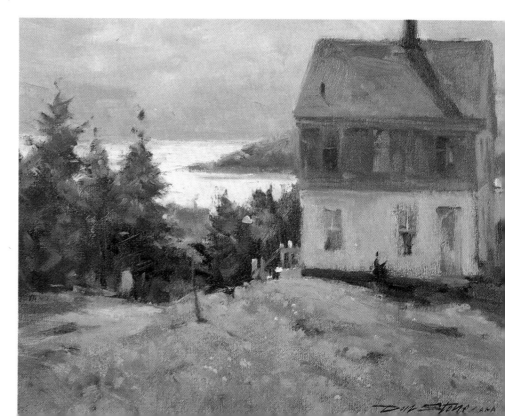

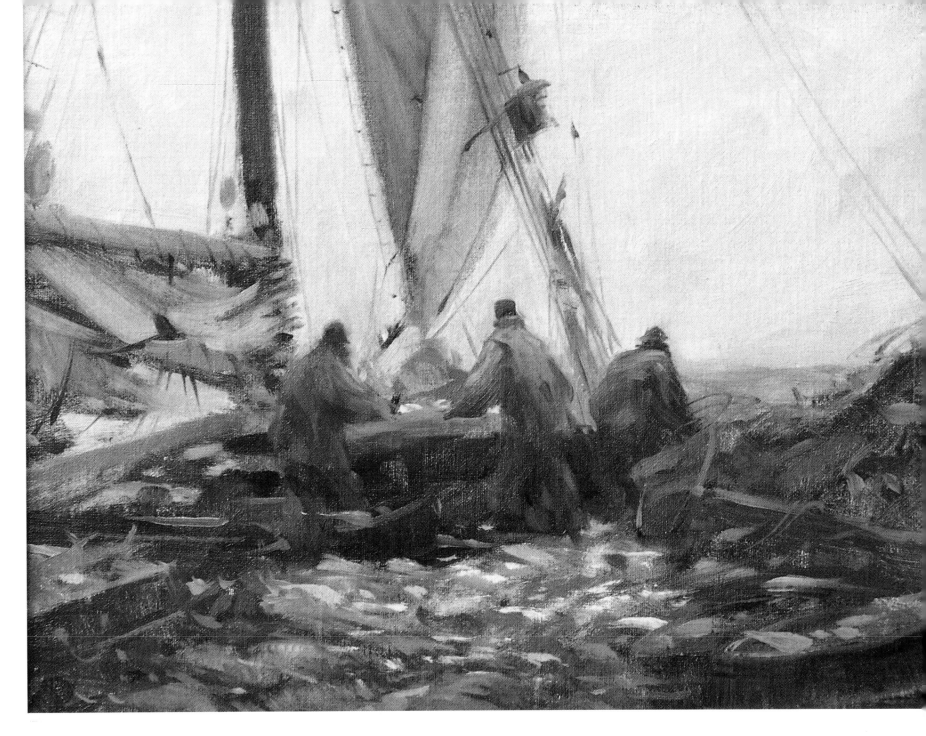

△ SPLITTING AND JIBING
8 x 10in (20 x 25cm)

This is a real action picture, painted with great authenticity. Don is in close contact with the fishermen and spends a lot of his time in boats. The gleam of the fish on the deck of the boat adds real vitality to this everyday Maine scene.

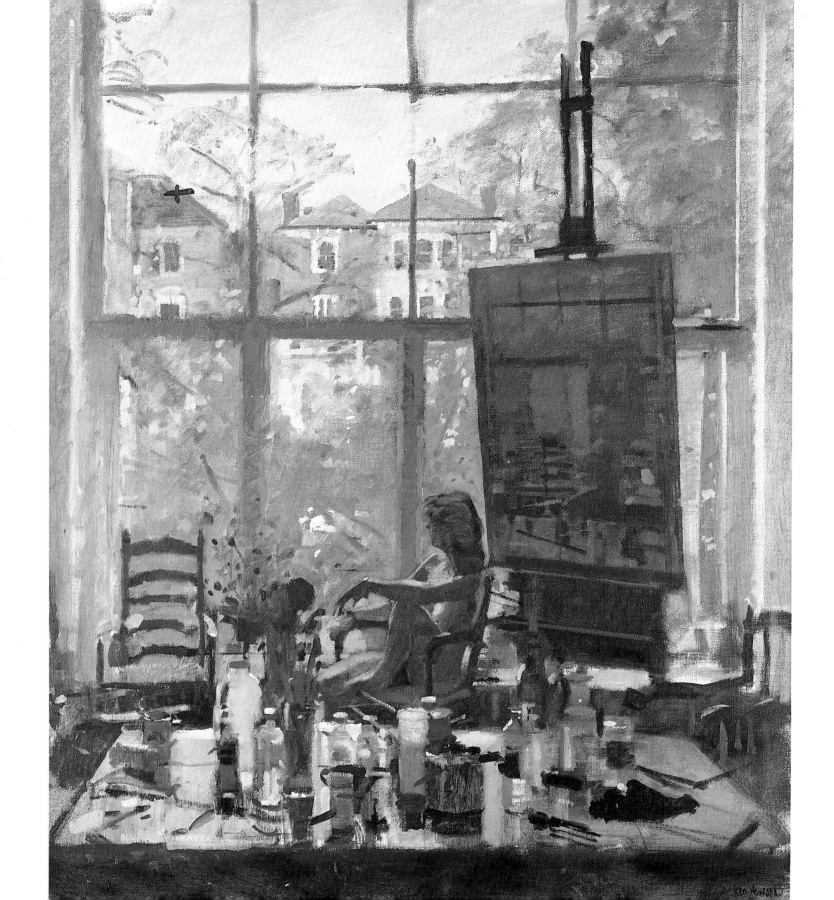

Ken Howard ARA, RWS, RWA

I first came to know and admire Ken Howard's work when I saw his paintings of Northern Ireland about thirteen years ago. He'd been appointed Official Artist by the Imperial War Museum, which necessitated him working out in the streets of Belfast and Derry at the height of 'the troubles'. He recorded dramatically, in paint, the atmosphere of tension and violence. He was stoned on one occasion, and often came close to being bombed. However, such was the nature of the man, he actually found his time there exhilarating. Having often taught watercolour in the same area I too have come to know something of that feeling! His paintings of Northern Ireland were superb and evocative, lending a new aspect and meaning to Impressionism, and these led to similar commissions in other 'trouble-spots' such as Beirut.

It was in fact in London during World War II that Ken took up art. As a boy, he went with his whole family to the shelters every evening, all of them taking something to do – Ken took his drawing materials. At the age of fourteen he found his first real subjects, which were the railway sidings at

◁ CHARLOTTE AT SOUTH BOLTON GARDENS
48 x 40in (122 x 101.5cm)
This is a good example of Ken's studio paintings, in which he often paints into the light. There's a great sense of depth, achieved by using pure contrast in the foreground and flattening out the values in the distant houses. The model is perhaps taking what is probably a well-deserved break.

Neasden, where he grew up. The excitement and movement of these industrial areas fired his imagination, as did the trains. Years later he found himself in Lucknow again painting steam engines, this time for the Indian Railway.

His work has always been in demand by large commercial organisations and the British Army, commissions which have taken him all over the world. The reason for his success is that his work is accessible – the man in the street can understand his ideas. This means a lot to him, because he feels that art is about communication and opening people's eyes to what he himself finds beautiful or interesting. He only paints what he loves, and what touches him visually. This, he believes, conveys itself in his paintings, and people are moved by them, whether they are beach scenes, scenes of Venice, or sombre wartime studies.

Ken was perhaps lucky to recognise his own aims in art from the beginning, feeling himself to be a mainstream painter in the tradition of Sickert, Ginart and Gore, who themselves followed in the tradition of the French Impressionists. This tradition called for an emphasis on sound draughtsmanship, the craft of painting and a passionate interest in the process of looking. Love of colour, and joy of handling the actual paint itself was also a vital part of this tradition of figurative art. It's hardly surprising that his work is immensely popular and that he sells virtually everything he paints.

In the past his work in various mediums has been seen by huge audiences. In the

1960s he was commissioned to travel the country painting pictures of individual post offices in villages, towns and cities, as posters for the Post Office Savings Bank (at that time most people kept their savings in the Post Office!). In turn this led to him illustrating the covers of all the telephone directories. He would produce pen and ink drawings of local features within each district, be it a cathedral, a guild hall or a shopping precinct, so virtually every home in Britain had at least one copy of Ken Howard's work.

Now Ken's international reputation is ensured, and he's in the fortunate position of working only on subjects of his own choice. His worldwide travelling is over, and he divides his time between his superb studio in south London, and his other studio in Mousehole, Cornwall, with occasional forays to Venice and Spain.

In Cornwall, his chief theme is the beach, of which he paints breathtaking pictures most of the summer. He seems to capture

49

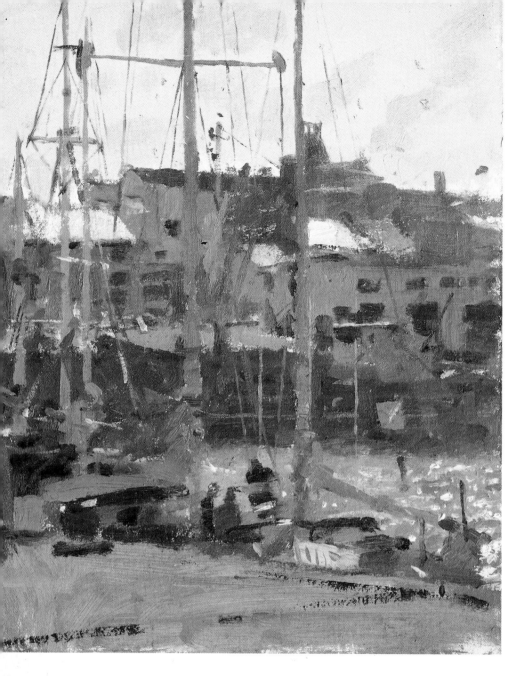

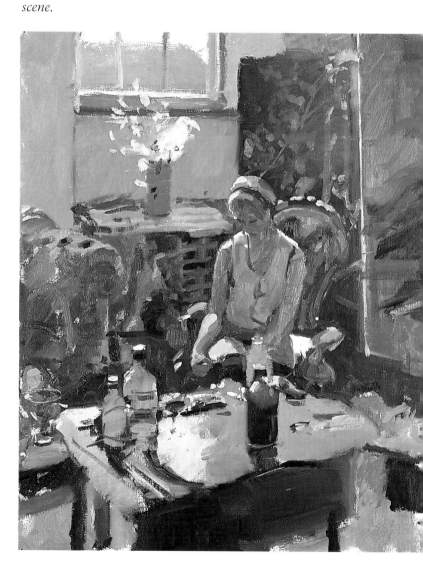

▽ LORRAINE AND THE VICTORIAN ARMCHAIR
30 x 24in (76 x 61cm)
The freshness and excitement in this painting has been achieved by balancing a highly contrasting foreground with a rich but more restrained background. He has also used edge lighting very cleverly to add vitality to the scene.

△ THE OLD HARBOUR, PENZANCE
10 x 8in (25 x 20cm)
This is another picture against the light. Through his choice of colour scheme he has managed to combine subtlety with sparkle, depicting a bustling scene by the use of strong, lively brush strokes and plenty of contrast.

50

the very essence of being there, often choosing one spot on the beach and depicting it in several paintings as it alters from morning to evening. He produces perhaps four or five hour-and-a-half paintings, complete in themselves and full of freshness and immediacy. He sometimes uses these as a basis for a picture on a larger scale, months later, back in his studio. He's found windsurfing to be a marvellous new subject with its sparkling, coloured wetsuits, the lovely shapes of the surfboards and sails and the daring movements of the surfers. He feels Boudin, an artist who has inspired him greatly, would have envied him windsurfing as a subject on account of its colour and movement. The brilliantly coloured wind-breaks and umbrellas, too, contrast well with the subtle greys of the Cornish beach scene, providing further opportunities for subject matter.

Ken shares his life with another painter, Christa Gaa, and he says that seeing Christa constantly in his studio completes his happiness. Back in his London studio, a new subject is absorbing him at present, which he calls 'light breaks'. He has a preference for painting against the light, and here he features beautiful girls, with parasols through which the light streams, flooding the studio floor with warm orange colour, just as at the beach the light is fractured by the wind-breaks. Perhaps this is his way of bringing some of the light of the beach into the studio.

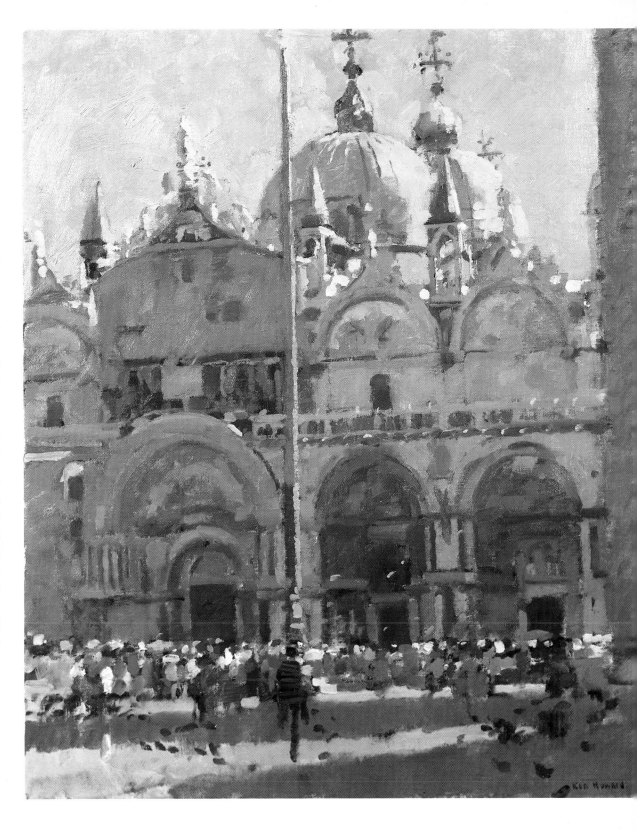

BASILICA, SAN MARCO, VENICE MORNING ▷
24 x 20in (61 x 51cm)
Although the façade is obviously in shadow, this hasn't prevented Ken from producing a riot of colour over its magnificent surface. Even brighter still are the economically indicated crowds. The two verticals help to balance a mainly horizontal picture.

51

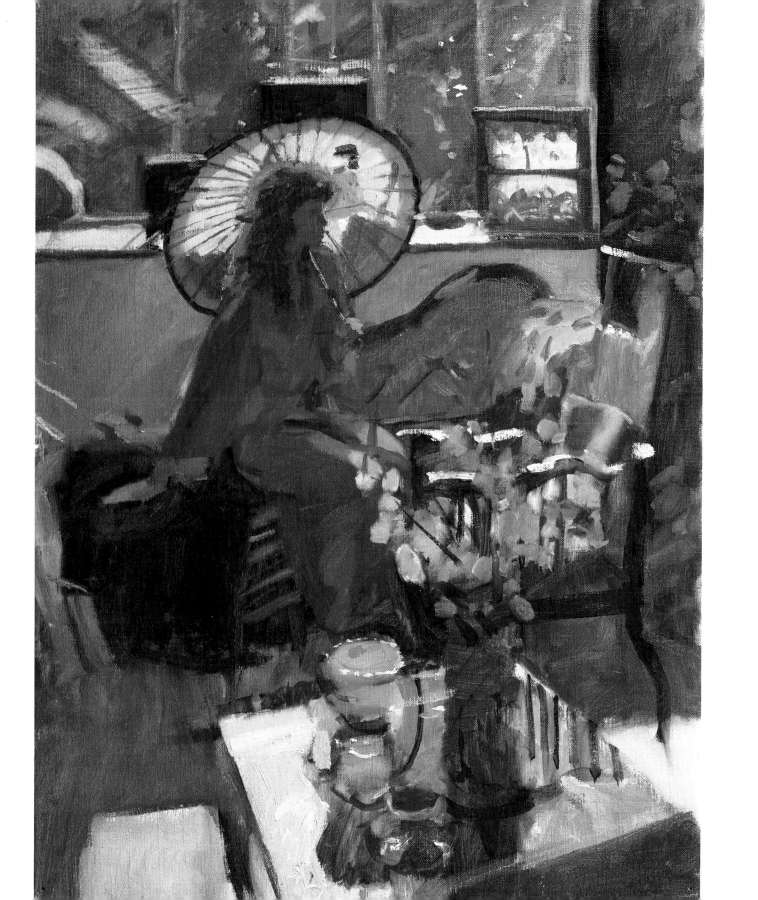

◁ THE RED KIMONO
48 x 40in (122 x 101.5cm)
*One can but gasp at the quality of richness
and excitement of colour achieved in this
magnificent painting. There's so much to
look at and gain pleasure from. A wonderful
example of Ken Howard's work.*

△ THE BASILICA, ANNUNZIATA, FLORENCE
14 x 18in (35.5 x 46cm)
*The foreground shadow is used to emphasise
and highlight the sunlit walls in the
background, a device which you'll notice is
totally reversed in the painting below. The
figures add depth and colour to the scene.*

◁ MARAZION BEACH
20 x 24in (51 x 61cm)
*Don't you love the singing colour in that
foreground wind-break? The whole scene has
an atmosphere of relaxation and gaiety. The
grey background silhouette tends to intensify
the light and colour in the rest of the picture.*

53

Doug Sealey ARAS

I remember, on one of my teaching trips to Australia, rising at the unearthly hour of four in the morning to be taken on a trip to the Blue Mountains in New South Wales. After travelling through breathtaking, rugged scenery we arrived at the old gold-mining village of Sofala – the whole place preserved much as it had been in its heyday. One could almost smell the dust of horses in its sleepy main street. Here I found an artist's studio and although the artist was away on one of his legendary painting safaris, I saw his beautiful paintings and bought as many prints of his work as I could to take back to England. That artist was Doug Sealey.

This man has become a superb artist against all the odds. Others in this book have achieved excellence by learning the skills from the finest teachers and schools. Doug did not experience this advantage.

Doug Sealey was born in smalltown Australia – in West Wyalong, New South Wales. At around seven years old he would plan with his mother how he would become an artist. The prospects were not good; it was

wartime, his father was abroad fighting, there were no art classes, and virtually no art supplies available because of the war. Art was not even on the school curriculum for boys in New South Wales at that time.

His first introduction to art was local pub signs. Most of them were of a high standard for commercial work, and were painted by artists who were later to become important on the fine arts scene. Doug often added another mile to the six miles he had to walk to school in order to study and admire his favourite pub sign. The lush greens in this particular scene fascinated him, as all the landscapes he had seen previously were of flat, scrub country, always as dry as chaff.

Over the next twelve years he picked up bits and pieces of information about art from expensive correspondence courses. Doug's big breakthrough came when he met Reg Campbell at an exhibition of his paintings in a department store in the town of Forbes. 'I spent all day, every day, at that exhibition,' Doug says, 'studying his paintings and neglecting my work at a gold mine my father had at the time. I can't ever recall being more happy – the smell of the paint and this new, exciting world of landscapes, portraits, flowers and seascapes.' He mustered up the courage to ask Campbell where he could buy oil paints, as in those days these were not available outside capital cities. The artist took him under his wing enthusiastically, showing him his studio and looking at Doug's paintings, telling Doug everything he wanted to know. It developed into a friendship which has, so far, spanned over 30 years.

Apart from his generosity, Campbell played an important part in Doug's painting career, controlling the works sold, sternly vetting them for quality and never consenting to a sale until he could see no room for improvement. This rigid discipline still holds. Every picture is a special product, even the small ones which are usually studies for larger works. Because of this intense dedication Doug becomes attached to each picture and finds it hard to part with them.

As the years went by his work improved rapidly and his reputation grew to the point where he was winning major awards and being sought as an art judge, as a tutor and by publishers for limited and unlimited edition prints and books. His pictures were soon being bought for the collections of leading banks and corporate companies in Australia and overseas, and even the Prime Minister's Department. However, to be a formally noted artist he felt he had to be in an important public collection and the break came when he was commissioned to paint four pictures for the 75th anniversary celebration of the Royal Australian Navy. These pictures are now part of the permanent collection of the Australian War

WESTERN RANGES ▷
30 x 40in (76 x 101.5cm)
Doug's genius lies in his ability to portray the enormous distances and vast open spaces of his country with sensitivity and love. The effect is achieved by the use of strong, warm colours in the foreground, and cool in the distance.

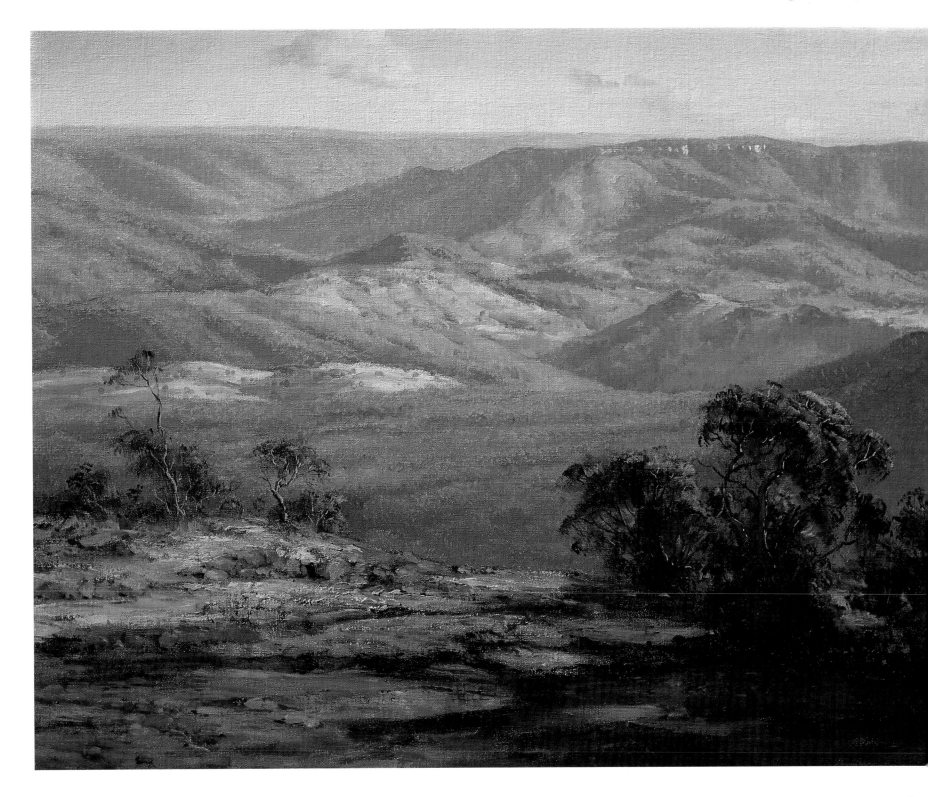

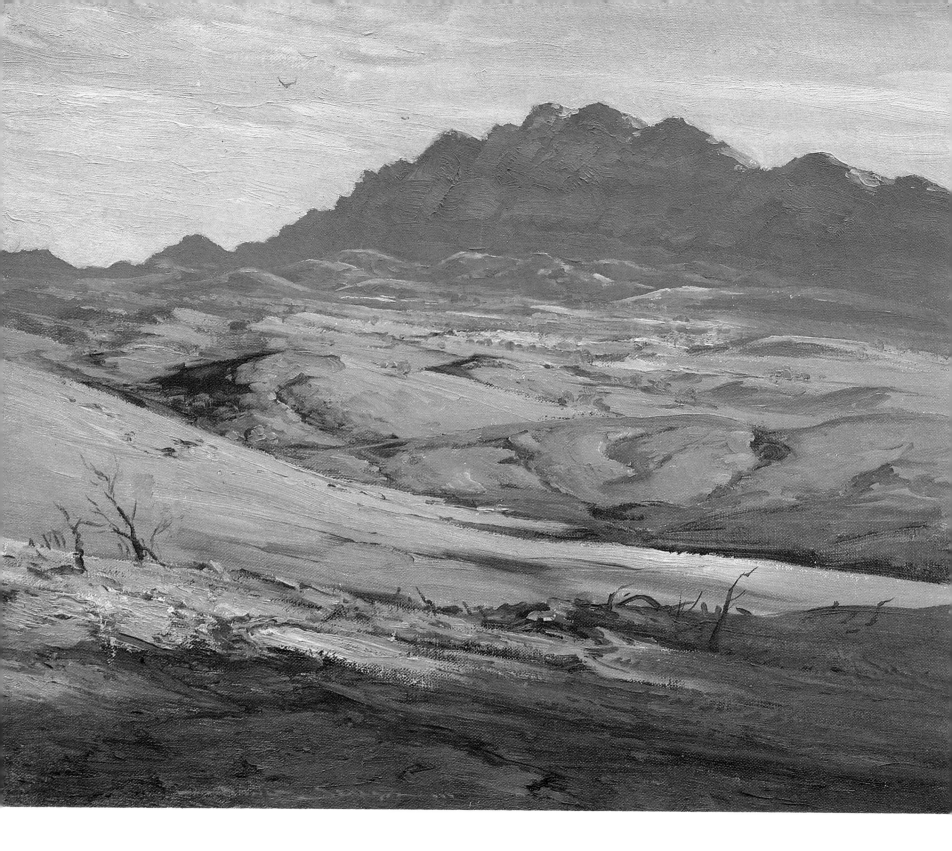

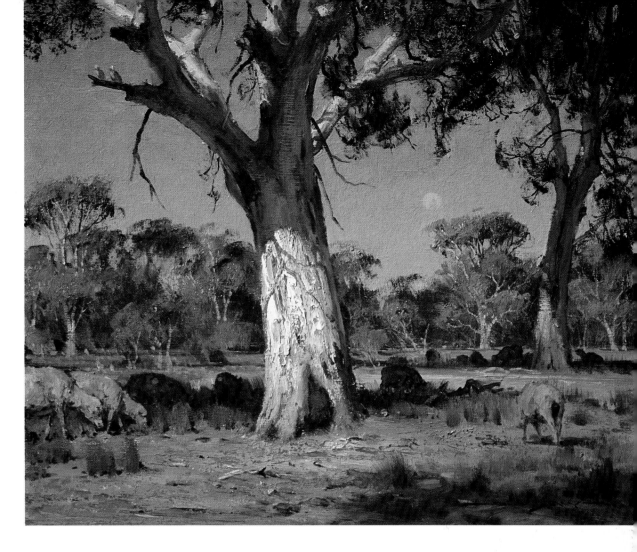

FLINDERS RANGES, SOUTH AUSTRALIA
20 x 24in (51 x 61cm)
Nothing could be more evocative of Australia than this magnificent painting. The colours are exactly right for this area and have been used to create the sense of vast spaces.

THE AUSTRALIAN GUM, FORBES, NSW ▷
20 x 24in (51 x 61cm)
The lighting here is particularly exciting – especially the dramatisation of the foreground gum tree which has been lit with a patch of sunshine. The sheep have been deliberately subdued in tone so as not to compete with the main subject. The ground at the front has been painted very warmly to give a sense of depth to the scene. Even the moon plays its part in the design.

Memorial in Canberra – the only permanent art collection in the nation.

My last letter from Doug says, 'Dear Ron, Sorry for being so long but I've just returned from a two months painting trip to the "outback".' This sentence typifies the amazing life this artist now has, with almost unlimited horizons. He travels to every corner of his vast country on painting trips. Many of these have lasted two years and covered 20,000 miles at a time.

Let me finish by letting Doug tell his own feelings about these working journeys through Australia:

I am constantly astounded by nature's infinite display of scenes – parading before me – stimulating my senses, linked to every part of my being. For when I am inspired by my world the emotion is felt all over, and no matter how tired I may be in the last picture of the day, I fly into it as if it were the first.

I see before me beauty everywhere – countless ever-changing moods, massive sea cliffs dropping sheer into the ocean, aggressive seas relentlessly pounding, casting soft sea mist up the Great Dividing Range, west of the coast, climbing through the giant mountain gums to the top of the world. I look out and see before me range after range. Rolling on, forever. There I stand in her cover of small vegetation (nothing big grows here). Always something new; at a blink of the eye it seems that these rugged craggy mountains can turn soft as silk in the afternoon haze. Further west, the inland rivers snake their way across the landscape lined with ancient gums. Guardians born before Christ, still standing. Warriors of time. Survivors of drought, fire and flood.

Further west the stark, silent outback where I am aware of myself, I hear my own breath. I hear my own heart beat.

Doug Sealey

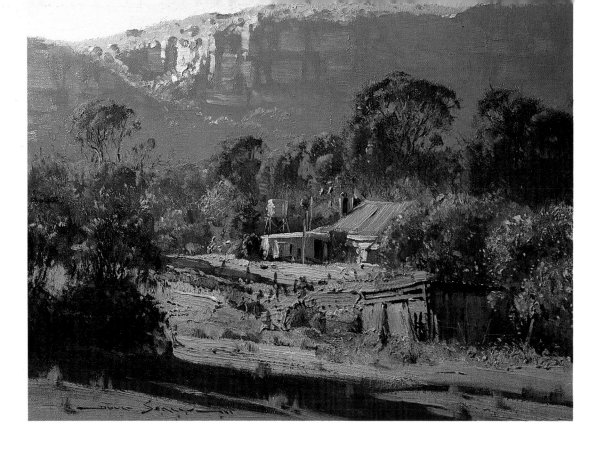

CAPERTEE BLUE ▷
16 x 20in (40.5 x 51cm)
The sense of vastness Doug creates in his work is extraordinary. The two planes have been separated dramatically by the use, once again, of warm and cool colours. The main object, of course, is the corrugated iron roof on the house, so typical of the Australian outback. The strong horizontal shadow is also an excellent device for drawing the eye into the picture.

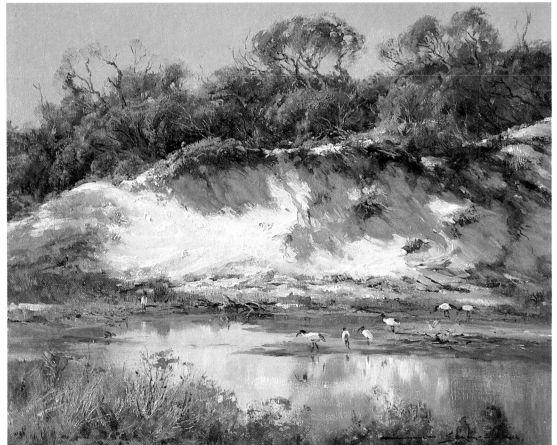

◁ **WHITE SANDS, CUDMIRRA, NSW**
16 x 20in (40.5 x 51cm)
This picture is exciting because of the counterchange of alternate lights and darks. The sunlit sand is made more brilliant by the dark trees behind it. The birds add interest to the scene, and the foreground grasses help to add another plane.

HILLS OF HOME, SOFALA, NSW ▷
24 x 30in (61 x 76cm)
Another typically Australian scene, with miles of depth. Here he has used very subtle pinks and mauves to achieve the effect. The strong colours have been reserved for the foreground trees and the patch of cloud helps to balance the picture. The viewer is invited into the scene along the track.

Everett Raymond Kinstler AWS

I envy this man – he seems to have done everything in art, learning, learning every step of the way.

Like most boys who grew up in the 1930s, he first saw art in the pages of books, magazines and comic strips and would pore eagerly over strips such as Alex Raymond's *Flash Gordon* (I remember them well in the *Eagle*). He was tremendously excited by the imagery and superb draughtsmanship of the many great illustrators of those days, and wanted more than anything else in the world to draw like them.

Just before his sixteenth birthday he made a fateful decision which shaped the rest of his life: he decided to leave school and try to enter the professional art field (at the time this was thought to be like running away to join a circus). Luckily he had loving and understanding parents who backed him up. World War II had created a manpower shortage, so he immediately managed to get a job as an apprentice inker at $18 for a six day week. It was a perfect first job, although at this point in his life he had no interest in painting or even in colour. Comic strips are usually designed and drawn in pencil by one artist, inked by another and finally lettered by another. He had to work hard inking in about eight panels a day, which was tiring, but it was an invaluable training for a young, aspiring artist. He learned how to portray action and mood in costume, drama, science fiction, westerns, romance – all quickly, simply, and on time!

After a year of this Everett also started to 'moonlight', doing illustrations for pulp magazines. At the age of 17 he left his first and last salaried job to go it alone. He was willing to have a go at anything and was given a tremendous diversity of assignments, having great fun and learning to become a professional. At the same time he thought he'd try art school part-time and, like a lot of other artists in this book, joined the Art Students League in New York. Here he came across the legendary Frank DuMond and his life took an important new turn. He elected to spend his afternoons studying with DuMond, a traditional painter who taught at the school for over 58 years and had a remarkable ability to inspire his students. Before this, Everett had practically no experience with colour and had never used oil paint.

Everett had a fruitful year drawing and painting from life and painting outdoors with DuMond in Vermont, all the time supporting himself by producing comics and illustration. He had to work far into the night, keeping himself going with black coffee and cigarettes to meet constant deadlines. Between these he spent every possible daylight hour learning to paint. As Everett said, 'Frank DuMond's influence on me was profound. He encouraged me and took a constant interest in my development. I first met him when I was 18 years old. Now, more than 30 years later, I still feel a deep and immediate debt.'

Towards the end of 1945, Everett was drafted into the army but by this time the war was over, and he had the time to produce a weekly comic strip for the army newspaper. Coming back to civilian life, he

FLOWERING POPPIES ▷
34 x 40in (86 x 101.5cm)
There's a remarkable strength and confidence in the strokes throughout this picture. Whilst there's overall vibrancy, the eye is immediately drawn to the red poppy on the left because it has been deliberately dramatised by the rich dark behind it.

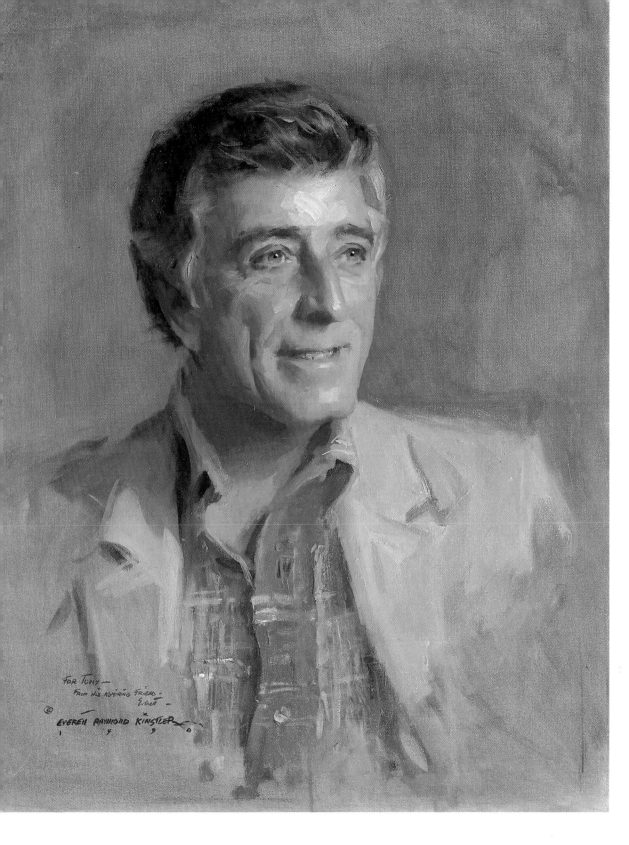

FOR TONY —
FROM HIS ADORING FRIEND.
EVERETT RAYMOND KINSTLER
1 9 9 0

went into book covers and magazine illustration, which paid better and gave more time for thought. After submitting five or six rough watercolour sketches to the art director, the final accepted painting was usually done in oils. As he summed up these years, Everett remarked, 'I'd say that an illustrator could almost always sell a picture that had the two 'Cs' – cowboys and cleavage, or both!'

In 1949, Frank DuMond found Everett a modest studio in his own building, the historic National Art Club in New York where he's been ever since. It was a milestone in his life, being immediately surrounded by the work and personalities of some of the leading creative people of America. Whilst illustration paid the bills, he made time to paint. He also took trips to Europe, filling sketchbooks with studies from Paris, London, Italy and the Alps and studying the works of the Old Masters. He returned from these trips excited and determined to paint without the pressures of editors and deadlines.

Slowly but surely as the 1950s unfolded, changes were taking place in American publishing. Photographs and graphics began to take the place of the illustrator, whilst at the same time Everett began to receive portrait commissions – really a natural progression for him. In 1958 he received a commission from Portraits Incorporated, a gallery devoted to representing leading portrait painters. This was the first of hundreds of commissions. He was now 'officially' launched as a portrait painter.

Over the years since 1960, his reputation has soared and he has earned most of his living from portraiture – indeed he has become one of the most famous portrait artists in America. He has painted from life over thirty-five cabinet members, more than

TONY BENNETT
30 x 25in (76 x 63.5cm)
(Opposite page)
This famous singer is a close personal friend of Raymond, and the painting is a fine example of his portraiture. Note the way the clothes have been simply indicated, which keeps the viewer's attention on the face.

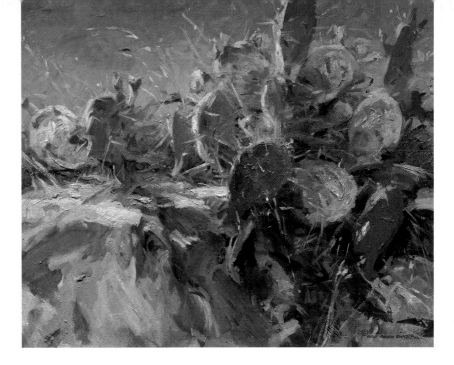

△ FLOWERING CACTUS
24 x 30in (61.5 x 76cm)
The confident brushwork has given this picture tremendous excitement, although it must have been a very difficult picture to organise in terms of value. The red flowers give good contrast and balance to all the greens. Raymond has managed to portray the spikyness of the cactus by his technique.

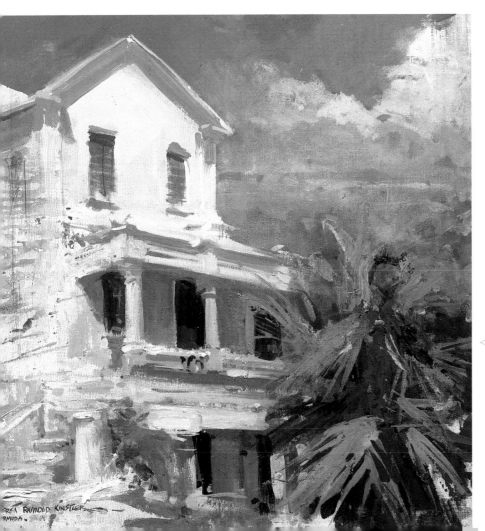

◁ FACADE, BERMUDA
26 x 24in (66 x 61.5cm)
I love the spontaneous brushwork in the building and palm trees of this painting. It is a good example of how simply a subject can be painted on the spot, suggesting detail with just a few strokes.

any other artist in American history. Four presidents have posed for him: Richard Nixon, Gerald R. Ford, Ronald Reagan and George Bush. Those of President Ford and President Reagan were the official White House portraits. Among over five hundred commissioned portraits have been such famous figures as John Wayne, Kurt Waldheim, astronauts Alan Shepherd and Scott Carpenter, Roy Rogers, Paul Newman, Tennessee Williams, James Cagney and Katharine Hepburn.

Of his work, Everett says:

It may look as if I've been switching around, turning my back on one field and launching another but I see all these changes as a logical evolution. I started with black and white line, learned about tone and finally moved into colour. I don't think more of portraits and landscapes than I do of comic strips – or less. They're all part of the learning process and fun and I'm still learning.

He works in the studio throughout the winter but when summer comes he needs to refresh himself both technically and creatively. This he achieves by taking painting trips to far-away places, and since 1969 this has been his routine. On his outdoor painting trips he starts out early each morning and gives himself half an hour to find a spot to paint. Then he stops wherever he is and paints something on the spot. 'Painting the obvious is easy,' he says, 'but it takes

sensitivity and observation to paint ordinary subjects around us, and the result is often greater artistic value than painting a subject that is obviously beautiful.' He paints in the early morning and late afternoon when the light is most luminous and fascinating. He generally paints for at least two hours and returns at the same time each day to continue the picture. He's not really interested in painting pretty pictures, but rather in sharing an experience.

Knowing of his whirlwind schedule, I managed to catch him by phone at 7am in his hotel bedroom in London. He was there to do some work for a British pharmaceutical company. At first he thought I was his alarm call, but we were soon talking about this book, which led on to talk of mutual friends, travel, painting, etc. Three quarters of an hour later we were still talking! Finally I put the phone down full of exhilaration and excitement – there was a real artist!

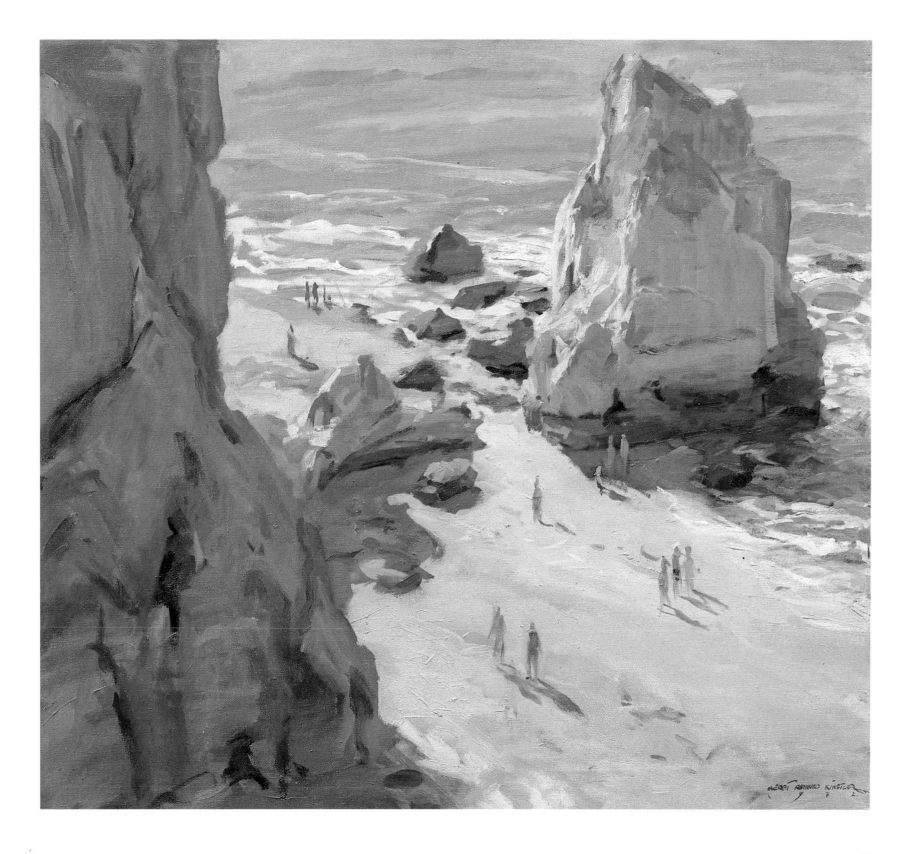

65

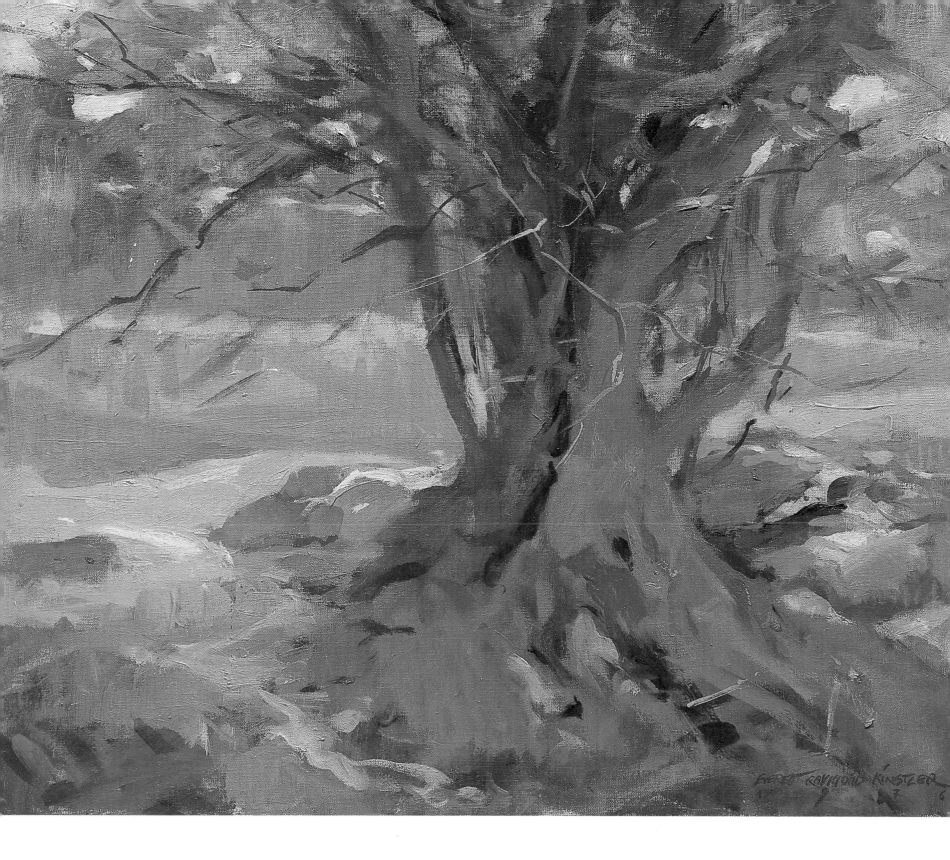

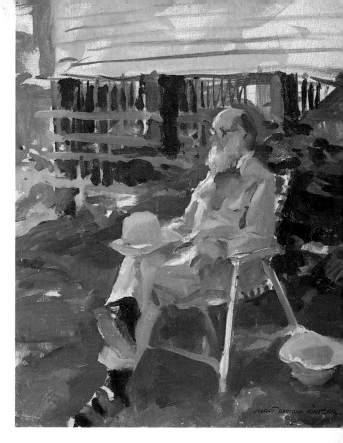

◁ THE TREE, CONNECTICUT
20 x 24in (51 x 61.5cm)
This picture was painted outside, using the fewest possible strokes, as can be seen in the tree and the bands of colour which form the background. By looking into the picture, you can see how much really bright colour he has managed to introduce even into the shadows, avoiding any possibility of monotony.

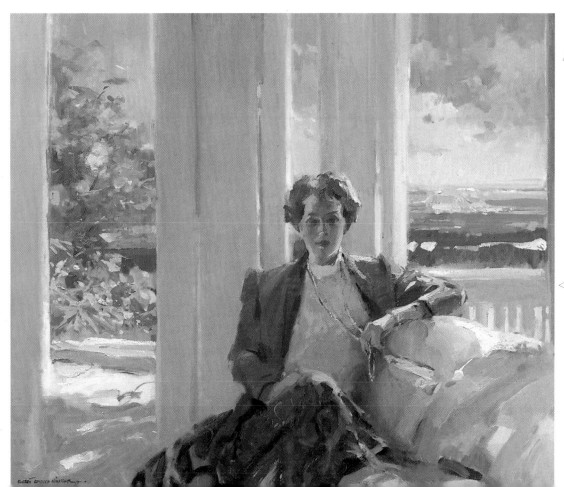

△ PORTRAIT STUDY
20 x 16in (51 x 40.5cm)
Although this picture was painted very freely, and in overall shade, Raymond has, by using edge lighting, conveyed the character of the sitter very strongly. I like the complementary pinks and greens. The clapboarding and lobster pots indicate that this could have been painted in Maine. I can't help wondering about the second hat, which certainly provides further interest.

◁ REFLECTIONS
40 x 46in (101.5 x 117cm)
This is a very finely balanced portrait. Look at the amount of colour he has managed to get into various areas – even the cream pillars and cushions are full of subtle hues – and yet he hasn't distracted from the main subject at all. A great feat of craftsmanship.

67

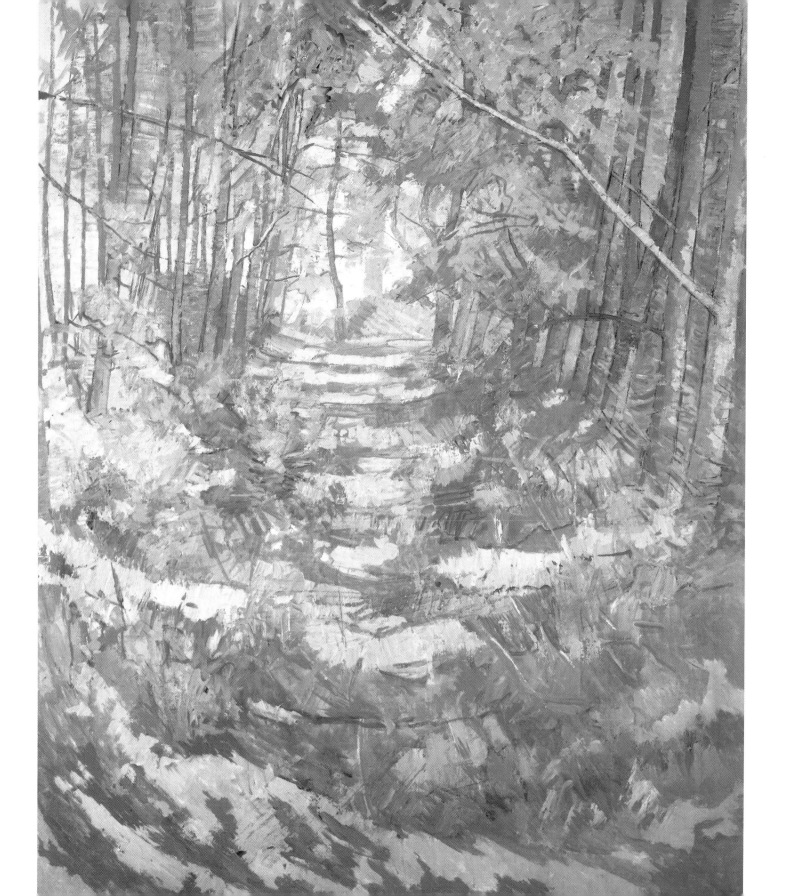

Sir Roger de Grey KCVO, PRA

Ever since my childhood, the letters 'VC' and 'RA' have held a fascination for me, and in my wilder fantasies, I've even imagined these letters behind my own name! The first is the ultimate reward for bravery, and the second denotes the peak of excellence in artistic achievement. I was delighted, therefore, when the President of the RA agreed to be included in this book.

Roger de Grey was born in 1918 at Penn, Buckinghamshire, the nephew of the artist Spencer Gore. He studied at the Chelsea School of Art from 1936 to 1939. During World War II, he served in the Royal West King's Yeomanry and the Royal Artillery, and in 1945, was awarded the United States Bronze Star. He resumed his studies in Chelsea after the war in 1946-47, and from 1947 to 1953 he taught, and was subsequently Master of Painting at Kings College, University of Newcastle. From 1953, he taught at the Royal College of Art in London, where he was first Senior Tutor and then Reader in Painting. In the Queen's Birthday Honours List in 1991, Roger de Grey was made Knight Commander of the Royal Victorian Order.

◁ LA TREMBLAISE
50 x 40in (127 x 101.5cm)
There's a particularly 'English' quality about Sir Roger's work here; it is restrained in colour and tone, yet masterly in its conception and execution. He uses no obvious shock tactics, but rather a quiet invitation to join him in his enjoyment of this tranquil scene.

Elected as an Associate of the Royal Academy in 1962, Sir Roger was made a full Academist in 1969, and became President in 1984. In subsequent years, his enthusiasm and energy, have brought about the transformation of this august organisation. He was intent on changing its image, from a well loved but essentially conservative institution into one which is vibrantly alive and worthy of the twenty-first century. He's active not only as a painter, but was also frequently seen clambering around the three storey high construction site at the brand new Seckler Galleries which were opened by Her Majesty the Queen on 10th June 1991.

In a typical week four days are spent at the Academy (the position, although prestigious, is in fact unpaid); another day he spends teaching at the City and Guilds Art School at Kennington, where he is the Principal;and the rest of the week, he paints at his home, a nineteenth-century cottage in Kent, which he shares with his artist wife, Flavia Irwin. Their other house is in France, on an estuary near Charente Maritime, and it is these two areas, that have formed the subject matter for most of his paintings during the last few years.

In England, he paints the close and intimate landscape of his studio and garden in Kent, sometimes combining interiors and exteriors in the same painting; whilst in France, he portrays the more extensive landscape of coast, and the estuary where the mudflats shimmer in the sun, and the light filters through the trees. Here, too, his paintings are high pitched and cool, almost bleached in colour and whilst his brushwork is free and impressionistic, the overall composition of his work is almost architectural in its stability.

His approach to his own work, he says, varies between geometry and feeling. His work may have been criticised in the past for his over-use of verticals, be they tree-trunks, window-frames or oyster-bed poles, but I find these visible bones of construction stimulating. Returning constantly to similar themes in his painting, he strives always to extract new variations in colour and structure to express his ever deepening feelings. As Sir Roger explains, these mean more as one gets older, and the whole object of painting is trying to express the wonder of being alive.

Sir Roger is not afraid of things being called beautiful, in fact he rather likes the word, but one word he doesn't care for is

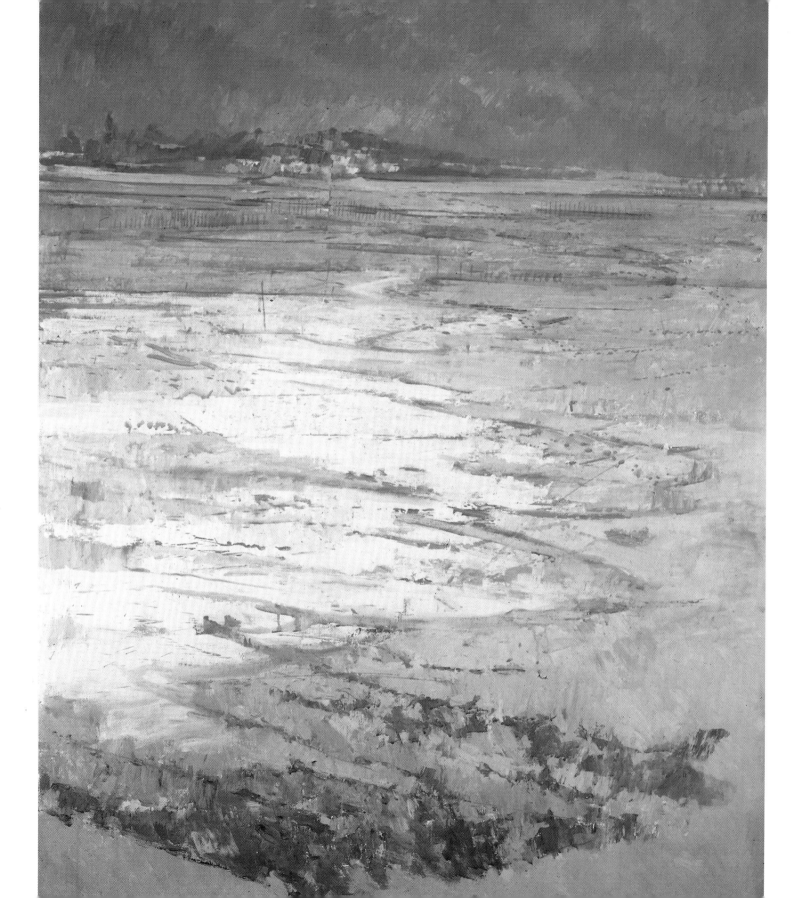

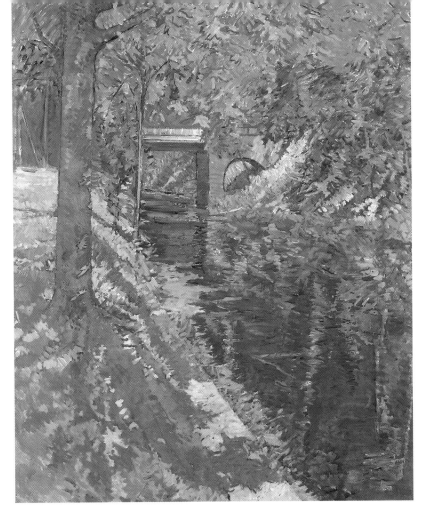

△ MARENNES CANAL — MORNING
53 x 43in (134.5 x 109cm)

*There's a much stronger design and colour to this
painting in contrast with the painting on the opposite
page. Look at the depth of reflected colour in the
canal, and the patch of sunlit bank on the left.
Characteristically, there are strong vertical elements
that contrast with the horizontal white bridge.*

◁ ESTUARY, MARENNES
50 x 40in (127 x 101.5cm)

*There's an almost dream-like quality about this scene.
From the bottom of the painting with its strong textural
foreground, one is drawn quietly up through the zig-zag
pattern of water to the distant village beyond. The
overall colour scheme of pinks and mauves has unified
the whole scene beautifully.*

▽ INTERIOR / EXTERIOR 1989
60 x 40in (152 x 101.5cm)

*This theme, of inside and outside views, features strongly
throughout Sir Roger's work (see also the painting on
page 73). The two elements have been cleverly linked by
the use of the hanging lamp and subtle colour has been
used throughout with great skill, to unify the whole
painting.*

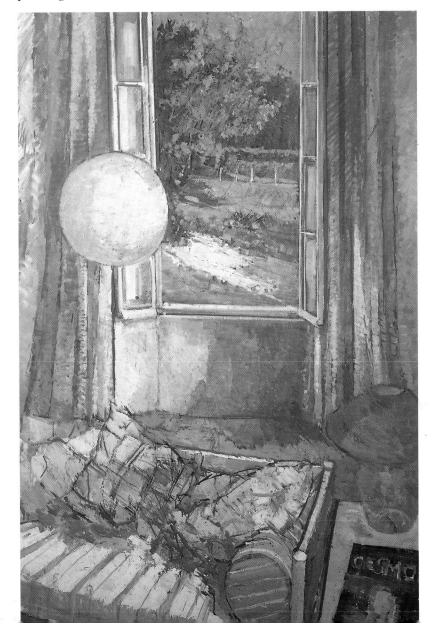

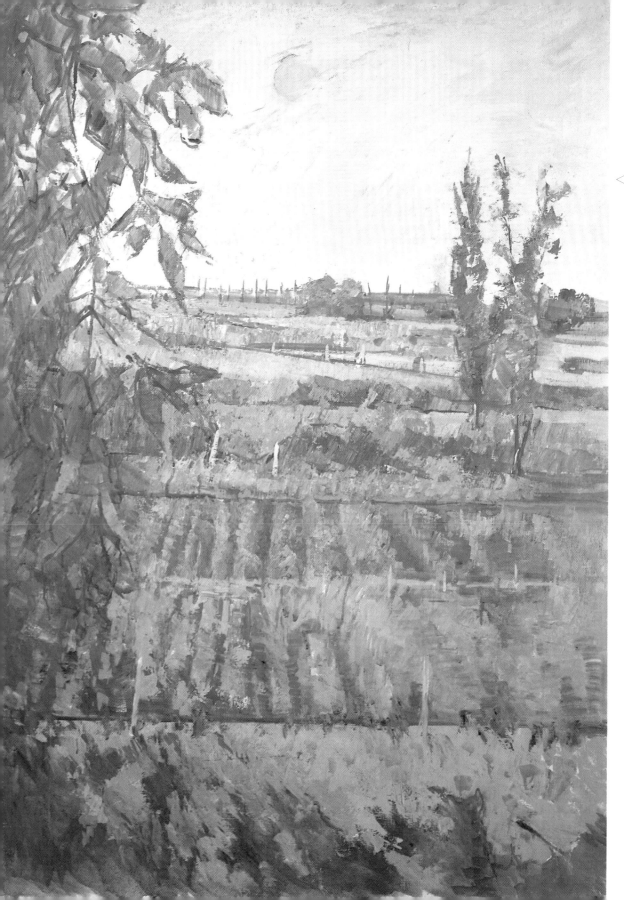

◁ ST SYMPHORIEN
Although this is an upright painting, it is a predominantly horizontal design, which is held together by the strong vertical tree on the left. There is a quiet elegance in the subtle colour scheme, which is combined with a strong textural feeling. Sir Roger's pictures repay generously the viewer's sensitive concentration.

sentimentality. He never sets out deliberately to arouse an easy emotional response from a spectator. His paintings are more a portrayal of his personal reactions to the locations in which he works – a feeling of poetry, rather than an exact reproduction of the scene in front of him. He never uses colour as a blunt instrument to dazzle the spectator into submission; instead, he extracts his colour gently from his subjects and modifies them according to the atmosphere which each place yields.

His overall approach is always to combine the best of old and new, for example in his home one might find an English eighteenth-century chair next to a mid twentieth-century coffee table. This shows too in his painting, where he uses traditional structure with modern techniques. As far as his leadership of the RA is concerned he says, 'I love the mixture of modern and old. My philosophy at the Royal Academy is to combine avant-garde and good tradition.' Sir Roger is passionate about art, about teaching and perhaps most of all, about the Royal Academy.

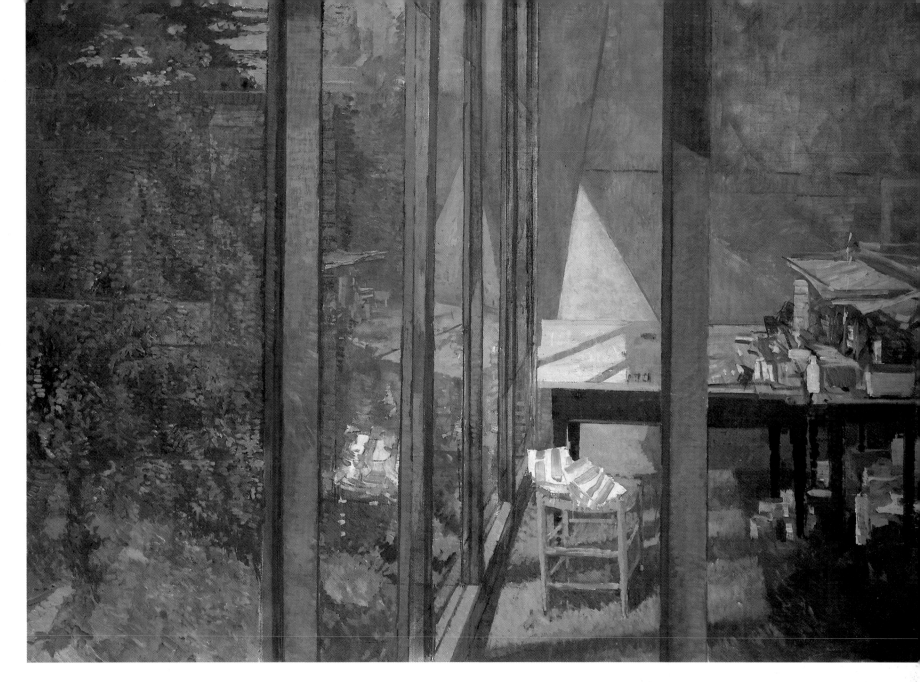

△ INTERIOR / EXTERIOR
54 x 72in (137 x 183cm)
There is a strong angular feeling about this painting with its uncompromising verticals. The theme of the picture is the two areas of studio and garden, which contrast enormously both in design and colour. They are, however, unified by the reflections in the glass.

73

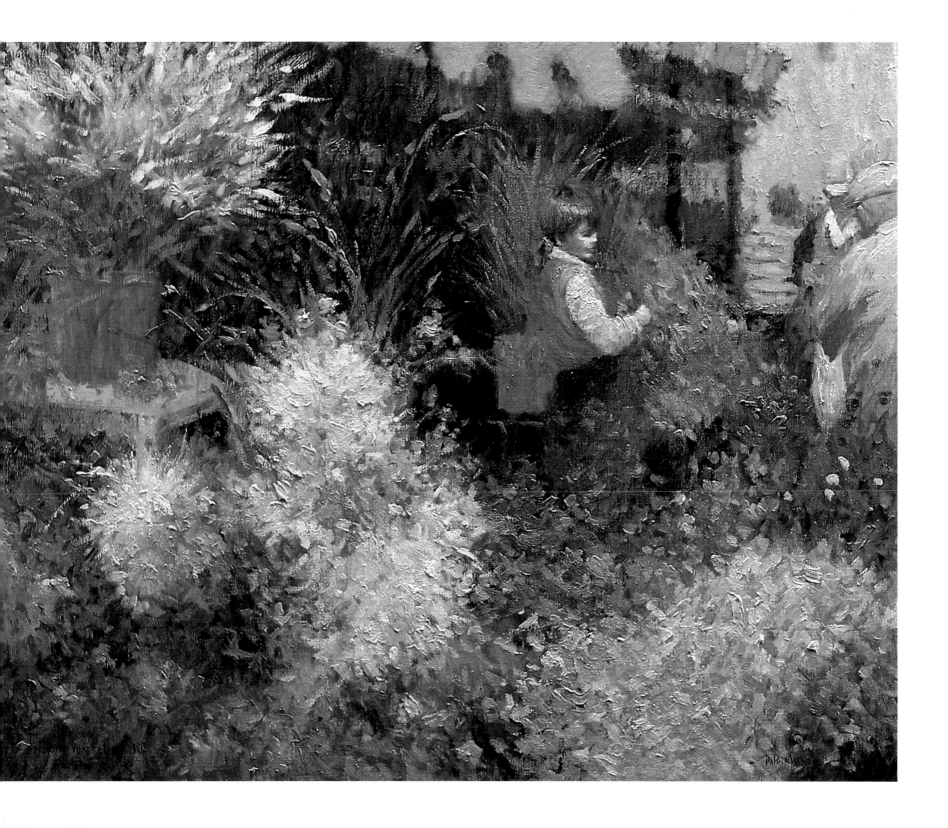

Dale Marsh

FLOWER MARKET, ST MALO
28 x 36in (71 x 91cm)
What better subject for displaying a symphony of colour than a flower stall, with its mauves, yellows and reds, all revolving around the counterchanged figure, the focal point of the picture. The other figures have been deliberately subdued so as not to distract from this.

THE FIRST DAY AT THE BEACH ▷
The child is the main object here, with strong top light and contrast. The other figure, although larger, is sublimated by lessening the value change with the sea. I love the soft mirror image in the wet sand. The woman's pink dress is complementary to the turquoise of the sea.

I'd been running watercolour workshops in Sydney and on my last day in the city whilst doing my souvenir shopping, before flying home, I came across a little art gallery. Once inside I was completely captivated by what I saw. It was an exhibition of the work of Dale Marsh, a man I'd never heard of. Immediately I felt that this was the work of someone whose painting seemed directly descended from that of the artists of the Heidelberg School. I was so excited that I rushed out and bought a book about his work, *The Art of Dale Marsh*, which has given me huge pleasure ever since. Now I want to share him with you.

Studying his life I came to realise that his road to painting had been a bumpy one, with at least one bad, near fatal, fall along the way. He started well – at the age of nine he won a scholarship offered by the Queensland National Gallery, enabling him to study painting one day a week for three years, under Vidah Lahey, a local painter and teacher. These years were, probably, the most important and influential period of his young life, during which he was introduced to and immersed in (through many visits to art galleries), the work of such artists as Sidney Long and Arthur Streeton of the Heidelberg School. Turner's work, too, was introduced, and had an incredible impact on him.

However after this promising start, and after some years as a signwriter, he began his training as an art teacher and this proved to be his undoing. He became completely confused and bewildered, first by the rigid stress on academic values, and second by the inflexible abstract doctrine of his lecturers which convinced him that everything he painted must be totally different from anything he had done before. He was taught that realistic painting was naïve and stupid: 'You'd outgrown it so much that you didn't even contemplate it. It was way beneath your dignity to go out and paint a landscape. That was something old lady housewives did. You are caught up in this prison of art intellectualism.'

The result of all this was that he just stopped painting. It wasn't until two years later that the breakthrough occurred, and to describe this I feel I can't do better than to quote Dale Marsh's own words:

I was sitting there that day feeling the

garden at Giverny

◁ GARDEN AT MONTVILLE
24 x 30in (61 x 76cm)

This is one of Dale's favourite techniques – almost burying tiny figures in a mass of greenery and flowers – but by skillful use of contrast and colour, he pulls one's eyes to them instantly – a very exciting game with the viewer. Look at the way the white dress reflects the green from its surroundings – only the hat and shoulders are pure white.

MORNING IN THE GARDEN ▷
24 x 20in (61 x 50cm)

A lovely painting. The top-lit figure is dramatised by the stong dark behind it. There's so much delicacy and lightness in the flowers that are being watered. The grey wooden table top doesn't intrude, and I love the subtle bounced light that moulds the girl's face from below.

environment, feeling that I was part of it. All of a sudden out of the blue I got this tremendously naïve urge to paint a picture of this tree. You can't do that, I thought, it's a stupid thing to do; someone might find out. Then I thought why can't I if I want to, it would be nice to do it just because I want to do it.

Immediately Dale drove all the way to Mildura, bought all the materials he needed and drove straight back again. He waited until the following day when the light was right and he painted his tree. He was pleased with the picture and with a few deft strokes of his brushes had been released from his intellectual prison. He had thrown all his academic confusions into the Murray and was painting again!

Today, Dale Marsh still paints a tree because he wants to. It is now more than twenty years since he last intellectualised his need to paint, twenty years since he decided that he had the right to see it all afresh without reference to anyone or to any theory, to paint light, form and texture as he saw it, instead of the way some critic or academic told him to see it. Now his work is continually sought after, and he has become one of Australia's leading realist painters. His work adorns the walls of national and regional galleries and major corporate and private collectors, both in Australia and abroad. In a recent letter to me he said:

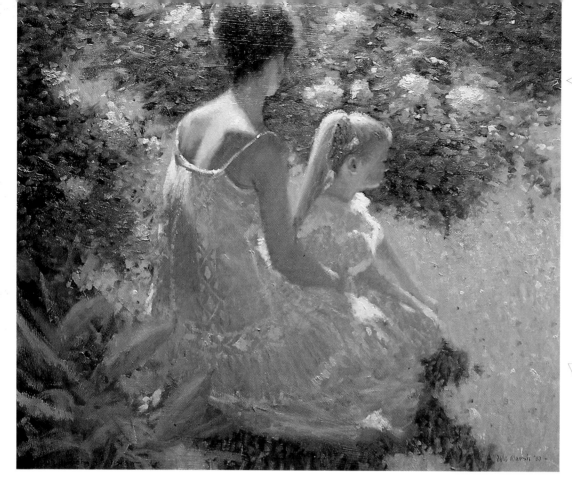

◁ WITH THE COMING OF THE ROSES
30 x 36in (76 x 91cm)
Dale has a genius for capturing grace and beauty by the subtle effect of top lighting and bounced light into shadows. That lace dress on the mother is superb - although in shadow, and with hardly any detail, it portrays a wonderful delicacy.

FLOWER MARKET IN THE RAMBLAS, ▷
BARCELONA
19½ x 23½in (50 x 61cm)
Although there is a wealth of colour in the flower stall, the main object of interest is the white-clad figure with the two King Charles spaniels on a lead.

▽ DEMOISELLES D'ANGERS
33 x 39in (84 x 100cm)
Note how the figure, instead of being strongly counterchanged as in most of Dale's pictures, has been blended into the shadows with only subtle touches of light thus giving a strong sense of unity.

The way I approach painting is firstly to open myself to the subject and then being open allow it to influence me. I try not to be conscious of technique when I work, preferring to concentrate on the feeling of the painting.

The right technique, and the right colours, are always there when I want them, they arise by themselves appropriate to the problem at hand. I spend a lot of time visualising the finished painting on to the white canvas. When I can see it down to the last detail, I am ready to begin painting.

Perhaps if we could all do this initial visualising, there would be a lot less wasted paint!

The flower market, Barcelona

Dale Marsh 1985

Summer's golden air

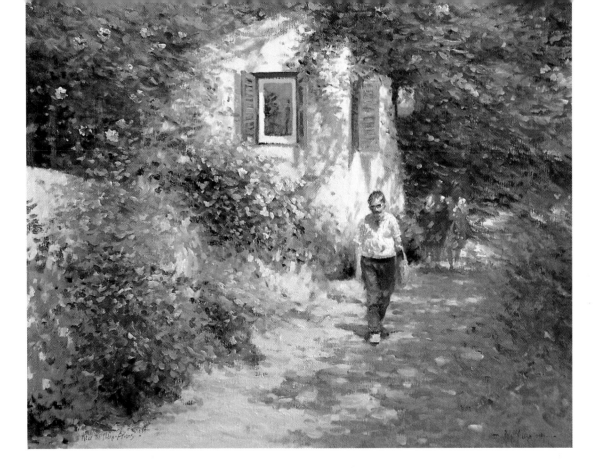

SUMMER'S GOLDEN AIR
15 x 19½in (38 x 50cm)
*The dog takes pride of place in this picture.
It is counterchanged against the white dress;
the girl is looking at him; and her arm leads
the eye to it – all very well thought out. The
hat, too, is important to the balance of the
picture. Try covering it up, and see what I
mean.*

△ NEAR THE PLAKA, ATHENS
30 x 36in (76 x 92cm)
*This painting, with its colourful shutters, has
all the flavour of Greece about it. Although
the figures are an essential part of the com-
position, they in no way dominate and the
viewer's eye is free to savour the warmth
and colour of the sunlit lane.*

◁ THE MOTH IN THE ORCHARD
28 x 36in (72 x 92cm)
*What a strange but mystical picture. The
plane has been used almost like a butterfly
on blossom – but why not; the aircraft is,
after all, a Tiger Moth. Overall the painting
is a riot of subtle colour.*

◁ IRIS
12 x 9in (30 x 23cm)
A very strong, boldly handled portrait of a vibrant personality. Much of the canvas has been roughly 'scrumbled' to create texture without distraction, concentrating the attention on the face. Even the hand has been merely suggested. Don't you love the earring?

CORNFIELD ▷
12 x 16in (30 x 40.5cm)
This painting is a fine example of what can be produced with a very restricted palette, which is compensated for by the use of vigorous, uninhibited brush-strokes, giving the painting great strength.

Delbert Gish AWS

Delbert Gish's philosophy about art is stern and unforgiving: 'If you knew you could never sell anything, would you still paint? That will tell you whether you're in the trap of working for money or if it's a pleasure for you to do it – for me it's much more important to paint for the spiritual rewards I get.' Coming from some artists this could be seen as an outward display of professional piety, but Delbert really means it! The quiet, deliberate tone of his voice is utterly sincere, though it can cause much consternation among his friends, those galleries wanting to sell his paintings and collectors who want just one more painting by Delbert Gish.

He also feels that equating sales with success is dangerous; 'An artist can make lots of money at painting and still not be adequate as a painter,' he says. 'Things come along – children with big eyes and tears dripping down – it becomes a fad and people buy them. That's success by one set of standards. To me, success is feeling that you have some worth and there must be something beneath it all.'

Anyone with these strong views is not in for an easy life, and he and his family have

had years of struggle as he has slowly built up his present reputation. His wife and four children have been tremendously supportive – modelling for him and being willing to make sacrifices so that he could devote his time exclusively to painting. Whilst not being sure that he can justify pursuing art over everything else, it's what he feels he does best: 'I don't always enjoy it but I'm more miserable if I don't do it.'

Even after years of study and hard work, Delbert feels that he never stops learning. Painting and sketching outdoors is a necessary part of Delbert's growth. He lives in an area of Spokane in Washington offering a wealth of subject matter. His home nestles among towering pine forests whose fallen needles cover its ground with a sound-proofing carpet.

Delbert Gish was born in 1936 and as he was growing up was greatly influenced by his mother. She had a great respect for Winslow Homer, the great American water-colourist, and encouraged her son to copy his work from an early age. During his early twenties, Delbert had a variety of uninter-

esting jobs but the real turning-point came when he decided to apply for a Stacey Scholarship Grant – a competitive award given to young artists wishing to study and work in the traditional manner. He won it, and was able to achieve his ambition to study for two years with Sergei Bongart, a Russian-trained painter with a national reputation, who worked in a realist tradition.

The first year was tough: 'Sergei was not very diplomatic in telling me how awful my work was,' he said. Slowly but surely Delbert

▽ THATCHED ROOF HOUSES, IN SAN ANTONIO, BELIZE
This Caribbean painting is a classical example of the use of warm and cool colours to indicate depth of field. Look at the cool grey-green of the hillside against the glowing warm thatch of the roofs. The foreground is full of interest and contrast.

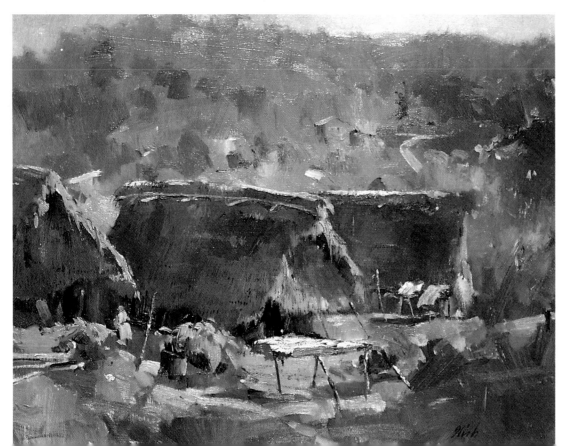

began to learn the fundamentals of colour and value relationship. 'Sergei took me to dinner every day and talked about Russia, introducing me to the works of the great Russian painters. There's a quality about Russian painting which is honest and earthy and the artist's feeling is evident.'

Delbert talks with great and sincere passion about his feelings for his work:

Over the years I became aware of something in painting which is more important than what can be achieved by applying paint to canvas. There is the joy of seeing and the consciousness of feeling something about what is seen. I don't minimise the importance of good painting but if the painting as a product were the most important thing there would always be disappointment since the work itself never quite measures up to the idea that pro-

ASPEN IN MARCH ▷
30 x 34in (76 x 86cm)
This painting contains some very clever lighting and texture, from the rich fore-ground, back across the surrounding waters to the distant sunlit trees beyond. The water has been made the main centre of interest, highlighted by contrast with the dark, adjacent trees.

duced it. One has hope that the next one will be better. There is a purity in an idea for a painting that can rarely if ever be completely expressed in a particular work. Nothing in art can be absolutely certain; one man's sow's ear may be another man's silk purse. But, I have a sense that people will generally have similar feelings about certain events. If this were not true there would be little point in trying to express ideas and feelings. When I feel deeply about something, I want to produce the same feeling in a viewer. This is one purpose of art. The question, then, about what to paint can be answered by saying, 'Whatever you feel deeply about'.

He feels there are obvious pros and cons about training at formal art schools, that school does influence a person – it's inevitable that if you study someone, or someone's work, you will exhibit some of the characteristics of that work. There's also the argument that rules and techniques of painting are so fundamental that you need to learn them before you can be fully creative. This belief is opposed to the modern opinion which says that you should enjoy complete freedom of expression, without the restriction of training or discipline. He also feels that this question must be looked at from both sides:

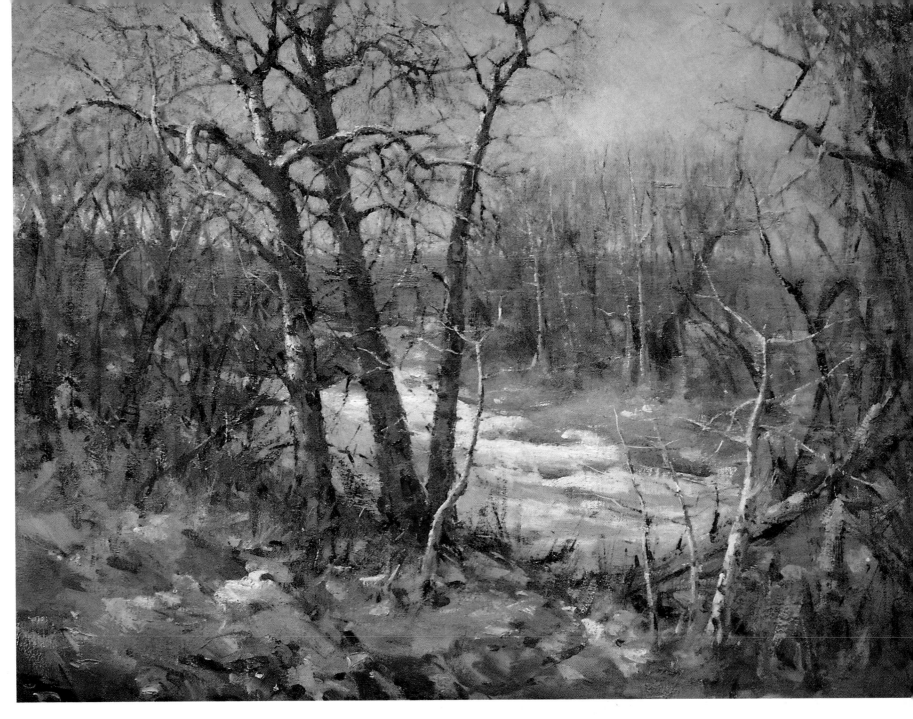

Perhaps too much training or discipline in one particular school is bad, but I personally feel it's much worse not to have any discipline or any understanding of the fundamentals of painting.

Finally, something about the man himself. Perhaps his character can be deduced from the fact that he served from 1984 to 1986 in the Peace Corps in Belize in Central America. Also, he and his wife recently spent a couple of years in New York working in a Times Square health centre that served homeless people. His wife worked as a nurse, and he carried out maintenance work whilst also teaching at the famous Art Students League in the city. Someone like Delbert commands my utter respect.

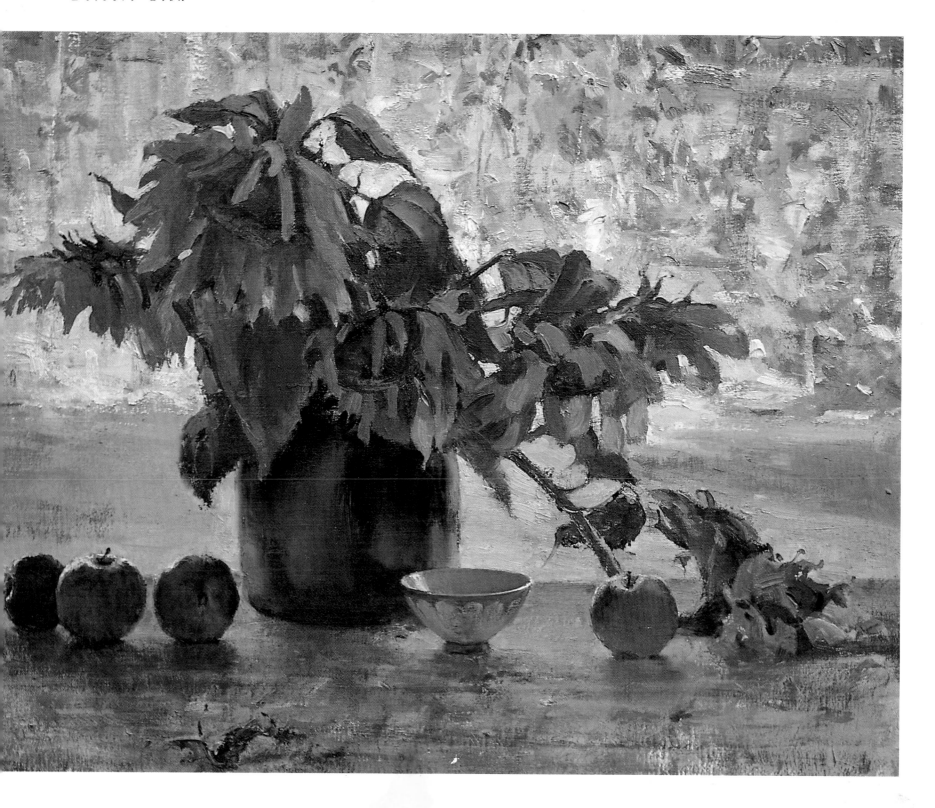

◁ SUNFLOWERS
20 x 24in (51 x 61.5cm)
This is a very strong 'against the light' painting. Delbert has avoided the temptation to capitalise on the brilliance of the yellow flowers; instead, he has silhouetted them to great effect against the sunlit exterior – so exciting.

▽ BELIZEAN MARKET
12 x16in (30 x 40.5cm)
A typical Caribbean market scene, the painting presents an intricate pattern of exciting lights and darks. The central figure of the stallholder waits, with infinite patience, to sell her produce.

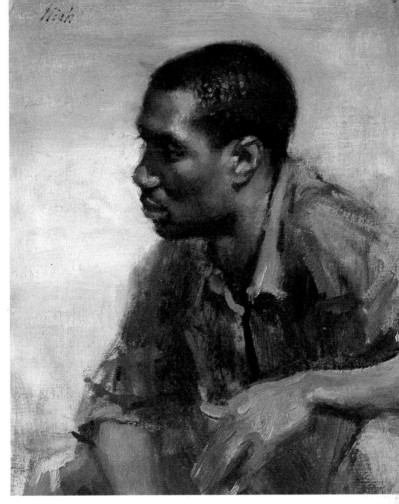

△ BLACK YOUTH
10 x 8in (25 x 20cm)
Delbert has skillfully used the brilliant area of light in the background to highlight the profile of the head. Good directional light from another source has also been used to mould the contours of the face itself.

Paul Strisik ANA, NAWA, AWS

Any artist who writes a book is bound to give some insight into his character and thinking as well as into his work. Such a man is Paul Strisik, and much of what is written here has been gleaned from his book *The Art of Landscape Painting* (I've had a very well-thumbed copy in my own library for years). For instance, a thought which I'm always hammering into my own pupils he puts in a very succinct way: 'Be prepared to be a student. Many students are impatient and don't want to serve their apprenticeship; they're anxious to enter shows, win prizes and sell their paintings. But all great painters began as students and more importantly *remained* students all their lives.'

Inevitably, painters mature in a slow and natural way. Unlike music and mathematics, there are no child prodigies in painting because painting is the total sum of the human being. It takes years of emotional experience as well as painting experience to mature as a painter.

Paul believes that hard work and determination make the painter. He dislikes the word 'talent', as I do myself, because it suggests that if you are born with ability you can achieve great things without working. 'Talent makes life easier but it doesn't guarantee success; it's like grease on a wagon's wheel – it makes it easier to get to town but you can still get there without it; you just squeak more along the way.'

He says: 'There's no magic formula to painting, just motivation and determination. You'll need that desire to excel and know what painting is all about – it's that elusive quality called taste that gives a picture the dignity that is common to all fine things. The difference between good work and a masterpiece is often very slight but these differences show in the hand of the master. A picture of a grand subject can leave you unmoved whilst a picture of a simple motive, deeply felt and well expressed, can bring tears to your eyes.'

He urges artists not to stick to the tried, well worn subjects – the red barn syndrome: 'Find a piece of nature and give it design and poetry, make it *your* picture, expressing *your* own unique vision of it. Rather a simple rock, painted with sensitivity and feeling than a canvas full of "grand opera" effects. If you let people see the drama of a subject, you let them see it through the eyes of an artist.' This, I feel, is another definition for 'impressionism'.

Paul's thoughts on arriving at a site are: 'What makes me stop and look?' Answer this question and you'll understand the personal significance of the subject itself. A painting is often more exciting than nature, because it's a distillation of the scene. It's even more truthful than reality because it's a frank expression of your own personal feelings; 'When you stand before a scene and say "that's beautiful" you don't even see the details at the moment you get that initial thrill. Only after you open your paint box and begin to paint do you notice the details. Your original conception didn't include an inventory of trivia, so why put such trivia in the picture?'

Paul paints freely and without detail – as he says: 'When you paint things *exactly* as they are you don't show people anything they can't see for themselves – you're telling them what they already know. The viewer, however, wants you to help them sort out the truth. Charles Hawthorne said: "The painter must show people more – more than they already see – and he must show them with so much sympathy and understanding that they will recognise it as if they themselves had seen the beauty and the glory." A painter's true craft is not making a literal picture of something but creating a faithful representation of an emotional experience.'

As to Paul's method of working, he says: 'I work on the spot, covering the canvas, but leave final decisions for the studio. Both inside and outdoor work contribute to the

quality of the final painting. Outdoors your adrenalin flows but in the excitement of the moment, you often miss subtle points that can be evaluated better in the leisure of the studio, where the details of the scene no longer distract you. However, I need that initial rapport with nature. It's like music – you can't play variations until you've learned the theme – then the variations will have the ring of truth.'

After serving in the US Navy as a photographer in World War II, he was discharged at the age of 27. He enrolled for three years in the Art Students League in New York under Frank Vincent Drummond and he laughingly remarks, 'That was the day I was

△ MORNING LIGHT
16 x 24in (40.5 x 61.5cm)
The sparkle of early morning light on the water is intensified by the surrounding darks of the dock, promontory and yachts. This is counterchange at its most effective. The wheeling birds add life and movement to the scene.

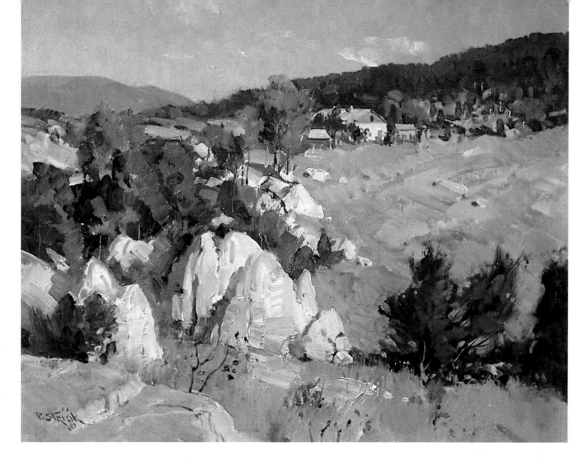

◁ AUTUMN JEWELS
24 x 30in (61.5 x 76cm)

The subtle and restrained colour of the distant mountains acts as a foil to the bright colour of the sunlit foreground trees. Notice how the river is used to take your eye to the centre of interest, the red barn. The white light on the water against the dark bank is also very effective.

born.' Then in his early 80s, Drummond was a rare instructor who awakened in his students an acute awareness of the painter's relationship to nature. He remembers Drummond telling the class: 'I may not be with you much longer, but I'll be sitting quietly in the corner of your studios in future years reminding you of these things.' 'And you know, he is – he has been teaching me ever since!' Paul says.

In his early 70s, Paul Strisik has two

△ WATERVILLE FARM

Paul never leaves us in any doubt where he wants us to look, and he uses his skills to control our eyes. The sunlit farmhouse and trees are spotlighted in a dramatic way, leaving the barn as a secondary subject. The path, too, plays its part in directing the eye.

◁ SUNNY LEDGES
16 x 20in (41 x 51cm)

The very strong brushwork and overall pattern of lights and darks helps to make this an exciting painting. Note, again, as in the opposite page, the use of a single touch of red to attract the eye.

91

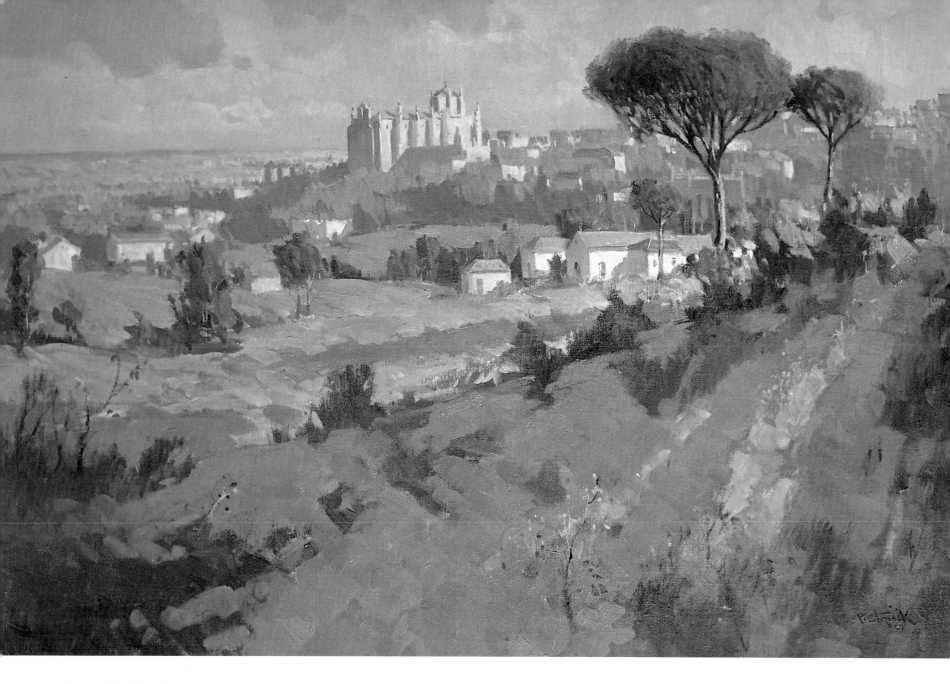

homes, both in picturesque locales: Rockport in Maine and Santa Fe, New Mexico. He also travels extensively round the world with his wife Nancy, in search of new effects and the challenge of painting new things. On his trips he paints on location with compact but portable painting gear, using 8x13in (20x28cm) and 10x14in (25x35cm) panels.

Painting thrills him! 'If someone asked me what the happiest moments of life are,' he said, 'it's when I'm out in nature with an easel and the hours don't exist. The complete moment of absolute happiness is when I start a painting outside.'

So far during his career, he has won over 150 awards – long may it continue!

△ MORNING LIGHT, TOLEDO (SPAIN)
Paul has used a very strong design element in this painting, taking the viewer by the hand along the shadowy foreground ridge, then turning it along the distant hill to the Alcazar. The colour of the cool foreground shadows is particularly interesting, contrasting boldly with the sunlit area.

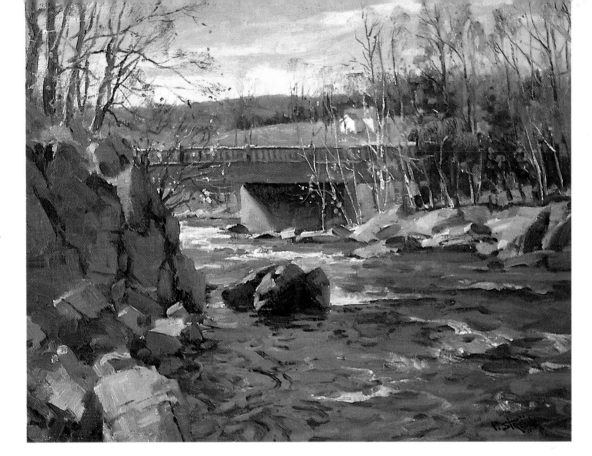

RIVER AT CHERRYFIELD ▷
16 x 20in (40.5 x 51cm)
The fast-flowing river takes the eye into the picture to the bridge. There is a great variety of subtle colour in the mid distant trees and far-off hillside. I like particularly the bounced light and colour in the right-hand vertical rocks.

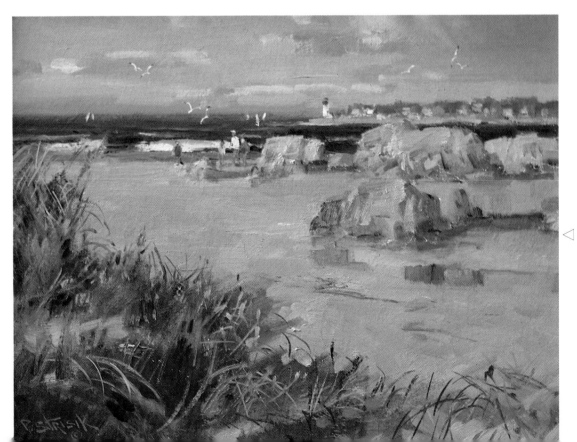

◁ WINGAERSHEEK BEACH
12 x 16in (30 x 40.5cm)
The rich foreground grasses frame the beach scene and the eye is led inexorably to the distant group of brightly coloured figures, surrounded by wheeling gulls. Paul has used the wet sand effectively to reflect the colour of the sky.

Ian Houston FRSA

I am sure many of you have realised by now that I'm probably the world's biggest fan of Edward Seago, the legendary Norfolk artist whose work inspired me to paint at the grand old age of 50 and thereby completely changed my life. I've since tried to repay the debt by producing two books about him. Tragically, he died in 1974.

Perhaps you can imagine my feelings, therefore, when I saw, at the Polark Gallery in London, paintings which had many of the qualities of, and were reminiscent of Seago's work. The artist turned out to be Ian Houston and I knew at once he had to be included in this book. A little later in conversation with Ian, I began to piece this fascinating story together.

Born at Gravesend, Kent in 1934, Ian spent his childhood on the Isle of Thanet.

He showed early promise as a gifted musician and went to London to study at the Royal College of Music for five years. During this time, he was also an enthusiastic bird painter. While browsing in the Roland Ward Gallery in Piccadilly, he met the Hon. Aylemer Tryon who persuaded him to submit some of his work to the gallery. He was so impressed that he asked Ian to become a regular contributor to the gallery.

The next turning point came about by another meeting in a nearby gallery, this time Colnaghi's Gallery in Bond Street, in 1956. Again browsing, he was asked if he would like to meet the artist of the one man show there, who turned out to be Edward Seago. (It was on the second day, so naturally everything had been sold!) The two

EDGE OF THE WOOD ▷
In this simple, predominantly cool snow scene, the eye is drawn inevitably to the bright patch of sunlit wood, with its warm, vivid colour. The curved lines in the foreground snow also lead the eye to it.

WINDSOR CASTLE / SUNLIGHT AFTER RAIN
10 x 14in (25 x 35.5cm)
(Opposite page)
I love this picture – the brushwork is so strong, vigorous and painterly. The dark clouds are rolling away, and the castle, spotlighted with strong sunlight, is so freely indicated yet there is no doubt where it is. Look, too, at the variety of rich greens on the trees and bank.

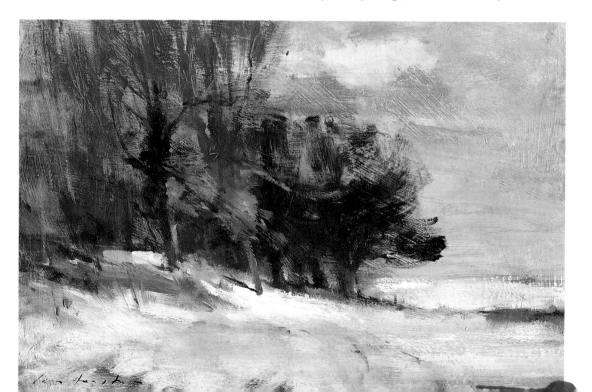

94

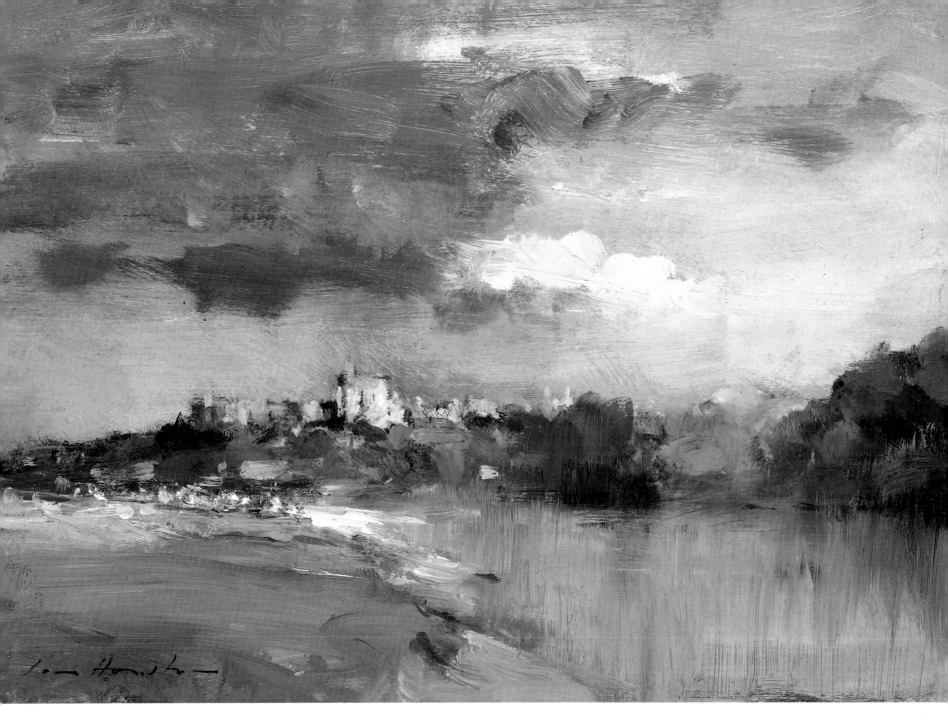

men established an immediate rapport. It happened that Seago was going off to the Antarctic to paint with the Duke of Edinburgh, on *Britannia*. But on his return, Seago asked Ian to stay at his home in Norfolk to paint with him. It was the first of many such visits during which he met most of Seago's distinguished friends, such as Field Marshal Auchinleck. During the next seventeen years he painted continually with Seago, even moving to Norfolk with his wife and two children to be near him.

Just before Seago died, he invited Ian to sail on his boat *Capricorn,* at Pin Mill. This voyage so inspired Ian, that he purchased

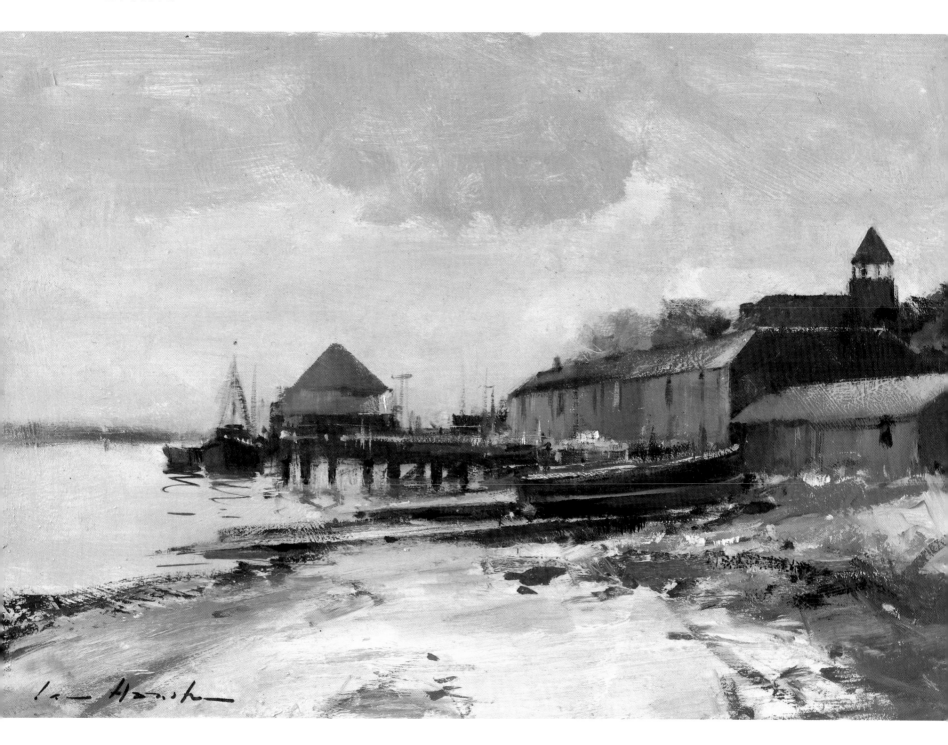

96

◁ DARBY'S HARD, GORLESTON
11 x 16in (28 x 41cm)

I saw this picture in Country Life *in a doctor's waiting-room and, not knowing the artist at the time, was immediately struck by the 'Seagoesque' quality of the painting. I'm afraid I surreptitiously tore it out. I like the quality of light, the subtle, restrained colour, and particularly the way the foreshore has been indicated.*

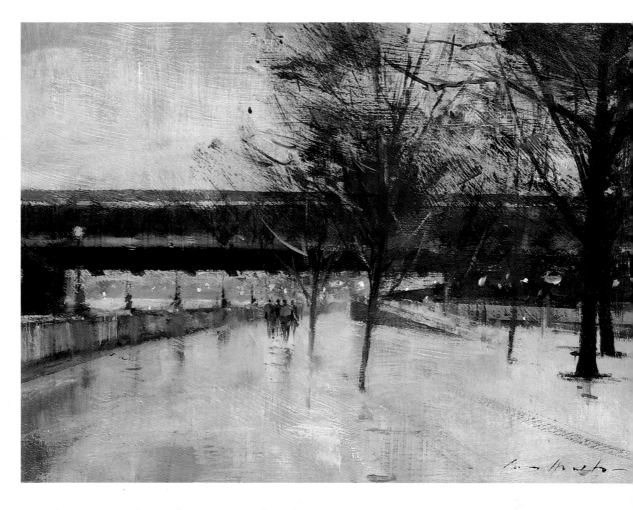

his own craft, a Thames spritsail barge. He subsequently qualified as a Master in order to study the coastline environment which forms the core of much of his work. By this time, Seago had persuaded him to give up his wildlife painting to concentrate on coastal and marine subjects.

Like Seago, Ian painted on site for many years, until he was able to retain visual information so that he could paint in the studio from memory; 'I go out, stalk the subject, and soak it in. I taught myself to memorise things by standing and looking, then turning round, closing my eyes and examining the inner image. The gift is the capacity to surrender to the scene, so that you can repeat it yourself by finding the image within.'

Whilst his first solo exhibition was in the Usher Gallery, Lincoln in 1964, it was at Mandells Gallery in Norwich that he was most successful. There he had an exhibition which was repeated annually for 16 years, from 1970 to 1986. He has also had a long association with the Polark Gallery in London, where he still holds a solo exhibition each November. He travels extensively and has exhibited in Cleveland, Baltimore and Houston, and also Jersey, Monaco, Bermuda, Adelaide and Melbourne.

△ WINTER EVENING ON THE SOUTH BANK
This is a very strong dramatic composition dominated by the bridge, although the trees provide a good vertical foil to it. The bright, wet street reflects the city lights behind it. One can almost feel the bleakness of the atmosphere.

Ian had just returned from his exhibition in Monaco when I spoke to him, where he had also given a piano recital – I wonder how many other artists have had the multitude of talent to achieve this.

Ian Houston

LANDSCAPE UNDER SNOW, NORFOLK ▷
This is a typical Norfolk scene, where the essentially flat landscape is dominated by the exciting weight of the sky, the rich colours of which contrast strongly with the sunlit snow below.

◁ THE OLD BASIN, HONFLEUR
11 x 16in (28 x 40.5cm)
This scene looks as if it were painted in late evening, with the last of the sun playing on the buildings and lots of strong shadows. I particularly love the limpid quality of the water in the harbour. Notice, too, how the church spire helps the composition.

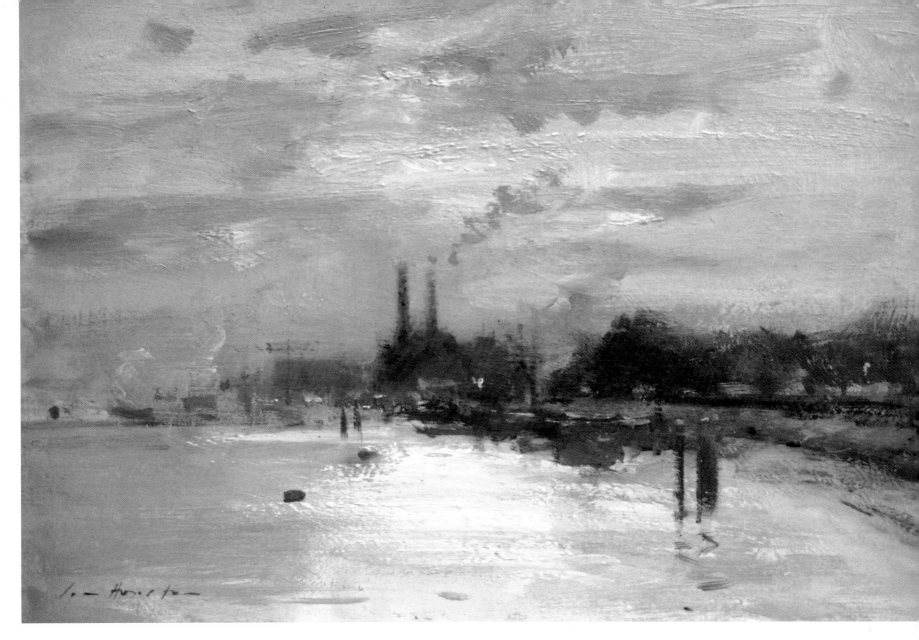

△ CHELSEA SUNDOWN
12 x 18in (30 x 45.5cm)
This very freely painted scene on the Thames is full of atmosphere. The light reflecting in the river is almost blinding. I like the dark mauves of the silhouetted buildings which complement the orange of the sky.

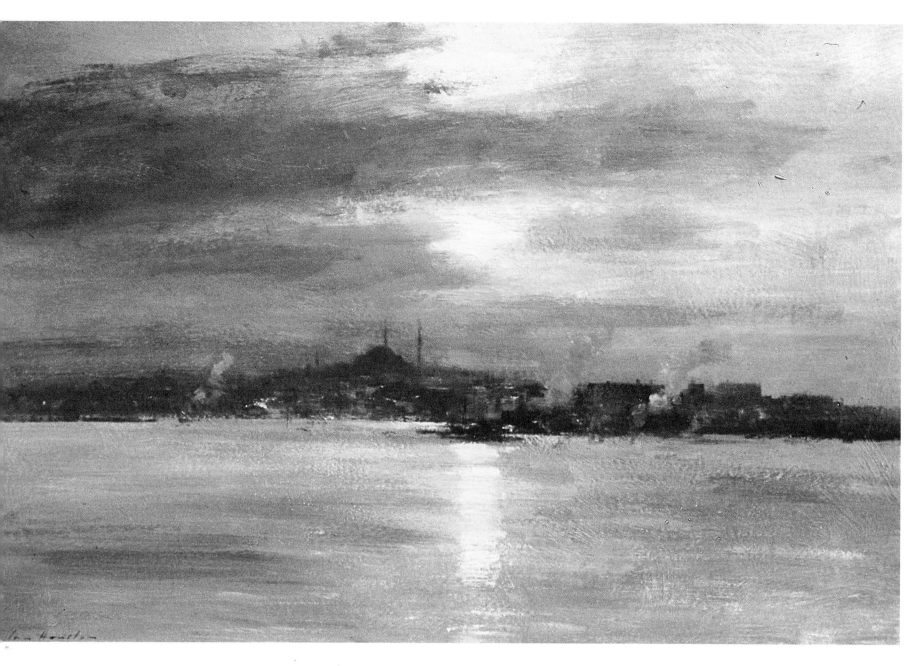

△ ISTANBUL, SUNSET
24 x 36in (61.5 x 91cm)
*Another sunset scene, but with a very differ-
ent locale. Although the sky is again freely
painted, there is great delicacy in the por-
trayal of the distant mosques and city.*

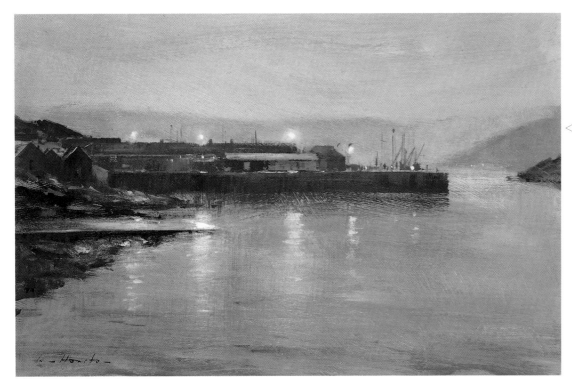

◁ KYLE OF LOCHALSH
11 x 16in (28 x 40.5cm)
Ian has created a wonderfully atmospheric painting of cold and mist, the bleakness relieved only by the harbour lights reflected in the sea. The sea itself has that oily quality one finds in such weather conditions.

IONA ▷
7 x 10in (17.5 x 25cm)
A painting full of contrast, the main centre of interest being the church. The foreground is deliberately in shadow, to take the eye into the middle distance. There is a great richness of colour in this painting.

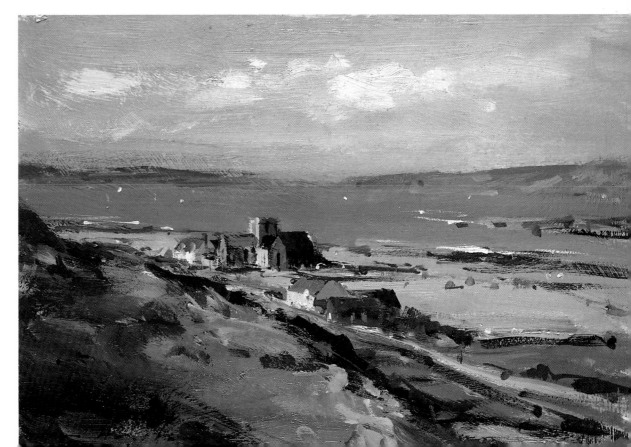

Walt Gonske

Walt Gonske is yet another graduate of the Art Students League in New York City, where he studied with the late Frank Riley. That same art school comes up over and over again when talking about the contributing artists in this book. There must be something very special about the place and its teachers. Walt left there to carve out a very successful career for himself as an illustrator in New York.

In 1972, he decided to move to Taos in New Mexico to become a full time painter. Again, this town kept cropping up when I began to write to artists whose work I admired for inclusion into this book. The town was 'discovered' by artists almost a hundred years ago. They were captivated by the unique colour and texture of the mountains, valley vegetation and streams. This, combined with the Indian and Hispanic cultures, opened a new world to them.

Today Taos is a thriving community, with new artists settling there all the time. Their paintings portray the town's superb, dramatic scenery. The town abounds with successful art galleries intermixed with shops specialising in contemporary jewellery, glassware and bespoke furniture. There's a marvellous aura of creativity and craftsmanship about the place which must be a huge bonus and incentive to a working artist.

So, for almost twenty years, Walt Gonske has enjoyed his life in New Mexico. In 1979, he was inducted to the National Academy of Western Art. He won a silver medal in oil in 1983 and, in 1989, their gold medal. During this time his reputation has grown, and with it his love for the area. His paintings are romantic, expansive, and infinitely rich in colour. He says, 'When I've tried to copy nature, the paintings have fallen short

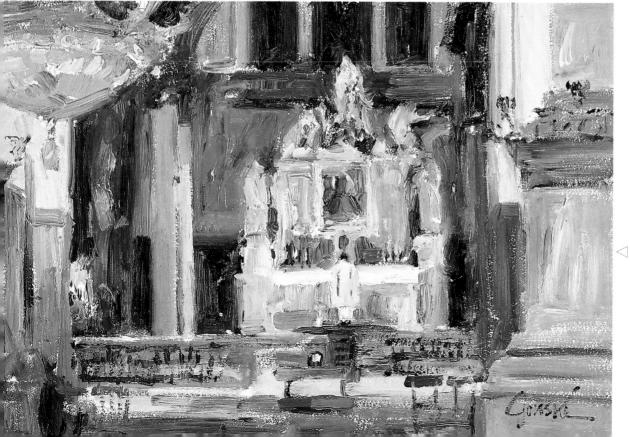

◁ BASILICA DE SANTA MARIA DELLA SALUTE
9 x 13⅛in (23 x 34cm)
This lovely, rich painting of an altar scene simply glows with colour, whereas most church interiors are dim and cool. It's so joyful and yet reverent. Just look at that gold lamp against the red and purple.

of my immediate impressions, so I exaggerate colour and value to capture the impact.'
His approach to colour is intuitive; a single painting might recall an extravagant range of temperatures, from hot pinks to chilling blues: 'There's no calculation in the way I mix paints; I really love colours, all colours, and I break a lot of rules. Many artists apply preliminary washes and then over-paint them, but I've been doing this so long I go straight to the finished paint. I like to get it all down before the mood and light change.'

This commitment to immediacy has led him to acquire a customised pick-up truck which he calls his 'Paintmobile': 'It's a Ford cab and chassis with a box-like camper which gives me plenty of space to work in all kinds of conditions, undisturbed,' he says. 'The recreational space is appointed with built-in racks for canvasses and special shelves for paint. I can stack fifty canvasses in there and over twenty-five tubes of each colour of paint. That's enough for about a month of work.'

Walter is as gentlemanly and ruggedly handsome as an Old West hero. He enjoys a reputation as a Western artist, but his range extends well beyond traditional narrative. 'I paint Western landscape, and in that sense I'm a Western artist,' but increasingly, his works reflect a very peripatetic lifestyle. He travels frequently to Mexico and further

SNOW PATCHES ▷
13 x 11in (33 x 28cm)
This picture is all about pattern and riotous colour. I love the bright blue snow shadows which complement the golden colour of the fields and the rich red of the cattle. Although the colours of the trees are obviously 'larger than life', they remain well within the character of the picture.

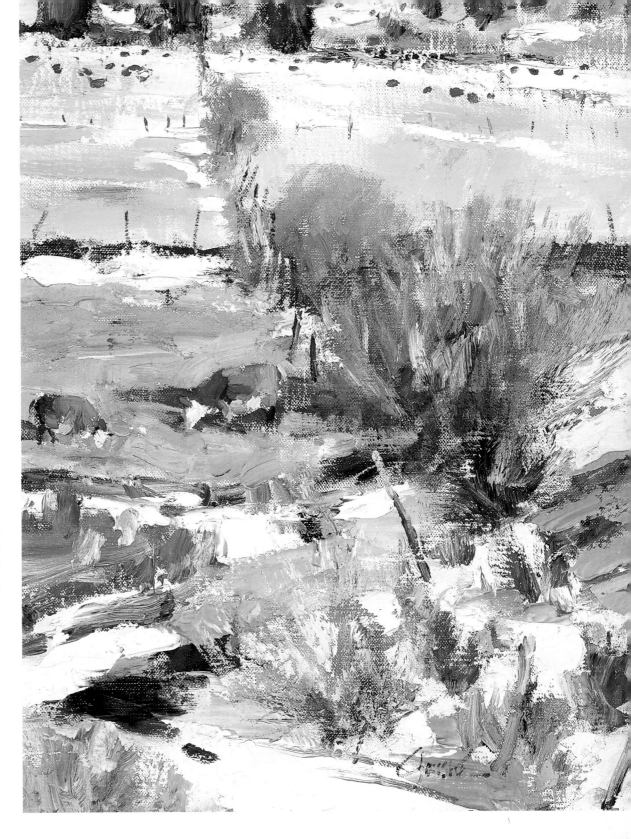

▽ TAOS PUEBLO LAND
14 x 24in (35.5 x 61.5cm)
I find the colour and sheer vitality of this painting breathtaking. Who would have imagined anyone getting away with that bright blue on the snow; yet he has accomplished it with great aplomb.

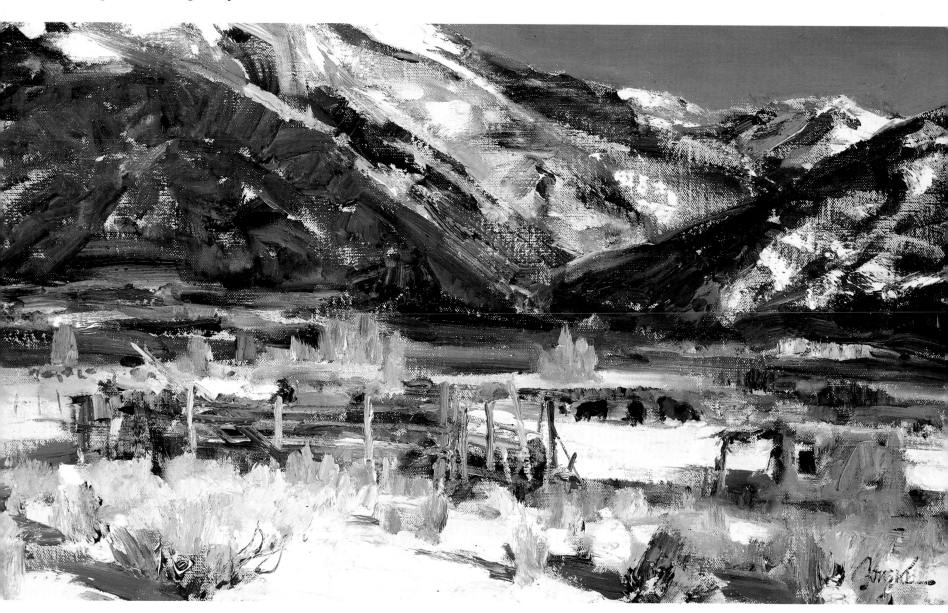

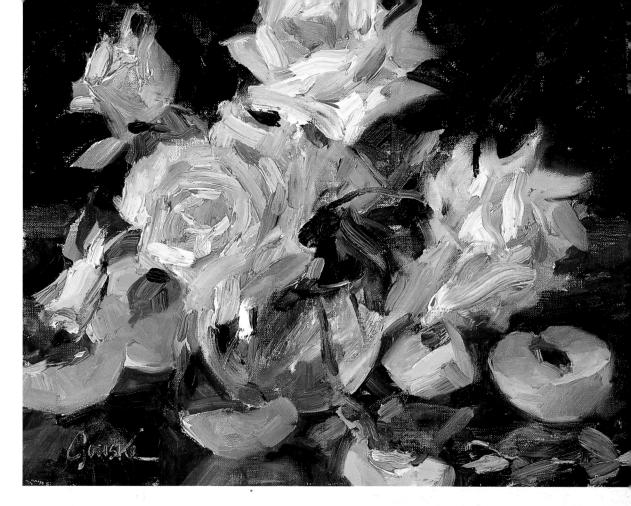

ROSES AND PEACHES ▷
14 x 18in (35.5 x 45.5cm)
Walt has obviously selected peaches and roses in a creative way to create colour vibration. Reinforced by the rich dark background, it would seem impossible to create more impact with paint than this!

afield to China, Portugal, and Italy. 'There's a big world out there,' Walt says. 'I hope to make major trips every spring and autumn, but I know I'll always come back to painting New Mexico again and again.'

Like the English artist Trevor Chamberlain, Walter has discovered the excitement and flexibility of the pochade box. He visited an exhibition in San Diego of paintings by Joaquin Sorolla in which a room was devoted to small oils, painted with a cigar-size paint box. Walter thought it was a good idea and had one made for himself. Shortly afterwards, he made a painting trip to Venice:

All my painting gear fitted into my back pack, and I was able to walk that wonderful old city stopping and painting whatever sparked my interest. Painting on the spot is for me one of my greatest pleasures. I like nothing better than to load up my van with art supplies and just take off, keeping as much as possible to secondary roads, constantly on the look-out for a motif that excites me – maybe the natural design elements in nature, interesting patterns of values or colour combinations which I respond to. Since most of my work is done like this, on location, I suppose this qualifies me as an impressionist in as much as I try to explain with paint my emotional response and the impression that the landscape has made on me. I seem to be moving further away from a literal translation of what's out there, and drawing more on my own personal feelings. This has led to a certain exaggeration and breaking of rules concerning colour value and even drawing. It's during this exciting and emotional process that I find painting most rewarding.

On a personal note, I find his completely uninhibited intense colour combined with his broad, free-flowing brush strokes give me a huge sense of pleasure and excitement, and a great desire to paint in this way myself. A final word from Walt: 'I get to a place where I'm totally absorbed for three or four hours. I paint, not for the pleasure of selling, or the praise, but for the doing, over and over again.'

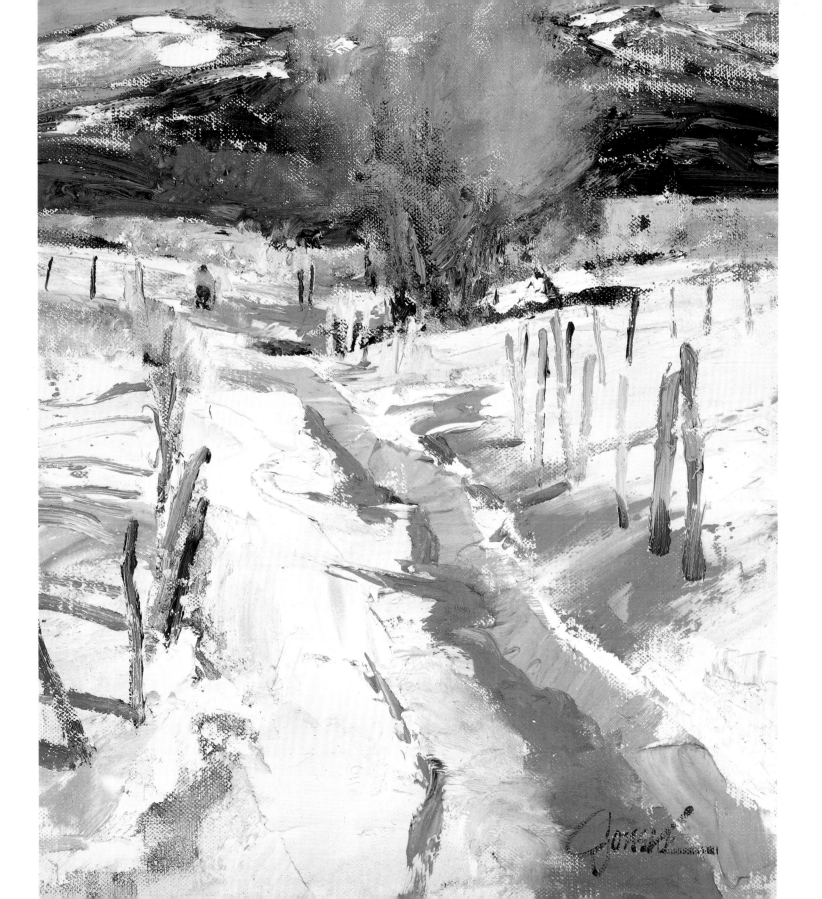

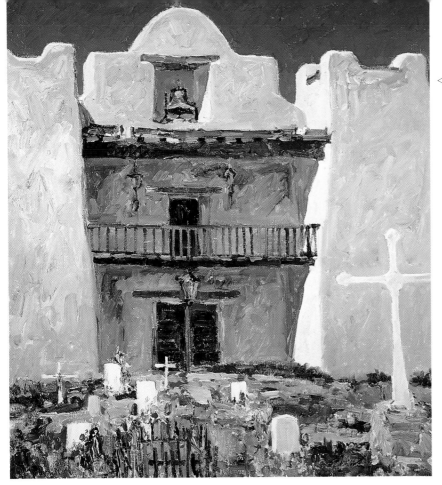

◁ OLD PUEBLO MISSION AT ZUNI
40 x 36in (101.5 x 91cm)
Just look at that sky – it couldn't have been that dark, but isn't it wild!? It has been used in a masterly way to throw up the profile of the church with its warm glowing walls; even the shadows sing. The large white cross helps to unify the foreground with the building.

▽ LAGUNA PUEBLO
24 x 34in (61.5 x 86cm)
The clear quality of light in this legendary part of New Mexico has obviously played a part in this painting, but Walt has emphasised the colours even more – just look at the central wall crammed with mouth-watering pigment. It's no use looking for subtle greys in this celebration of colour and light.

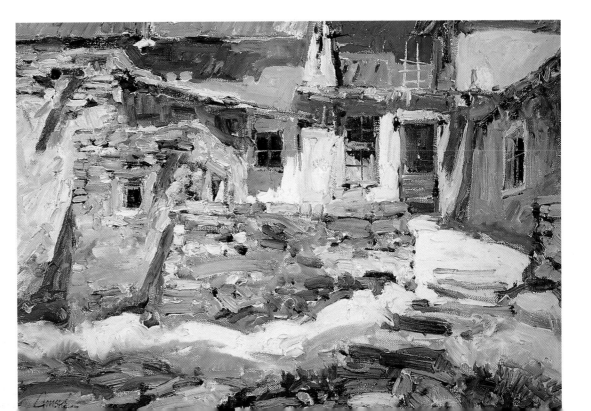

◁ TIEPRA AMARILLO WINTER
With this much impact, this painting just had to go on the back cover as well! The viewer is left no option here but to follow the track up to the distant figure whilst being rewarded with the singing colour on all sides. I love the way the warm and cool pinks have been used together on the tree.

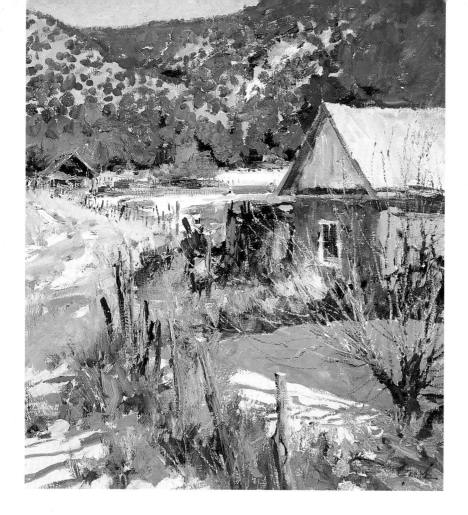

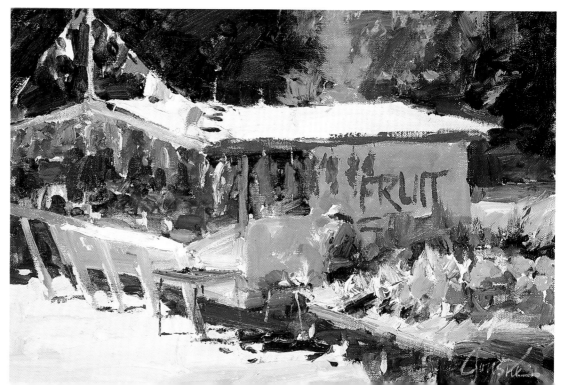

▽ FRUTA DE ANA AMARIA
14 x 20in (35.5 x 51cm)
Not a colour has been spared here but all used with great purpose and skill. This subject could easily have become merely gaudy but there seems to be a hidden discipline and good taste about Walt's painting which just avoids this, while still producing excitement.

△ ALMOST TO LLANO, NEW MEXICO
30 x 26in (76 x 66cm)
Walt has used soft background greens, rare in his pictures, but only as a means of emphasising the pure richness of the foreground colours, mauve against orange. Notice how the eye is carried by the nearby posts to the road and thence up to the distant hut.

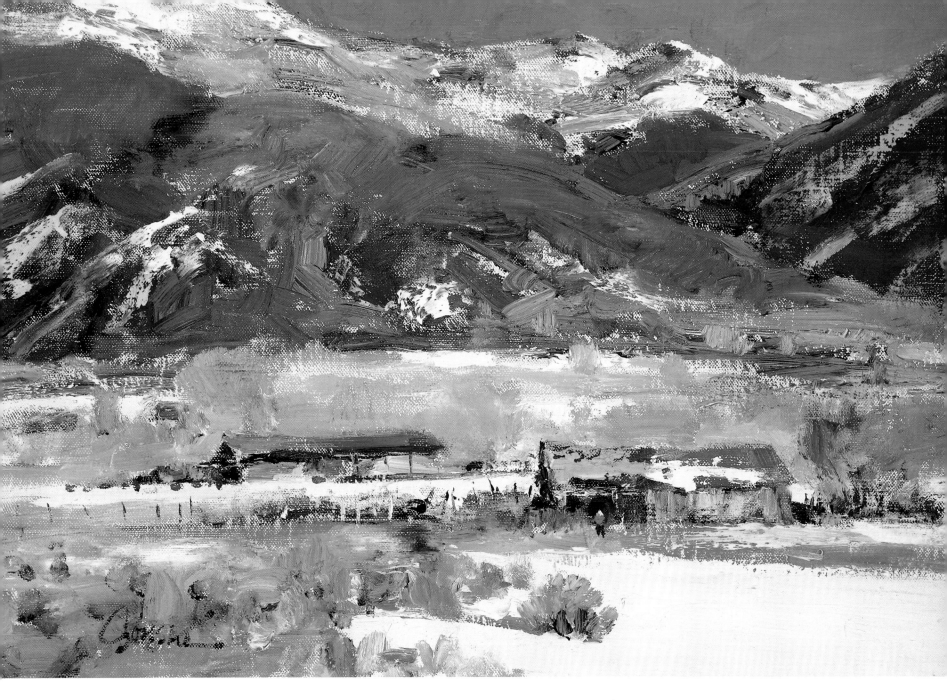

△ DES MONTES
13 x 19in (33 x 48cm)
Walt seems to break all the rules here by painting rich, dark, vivid colours in the background and soft subtle ones in the front, but he gets away with it magnificently.

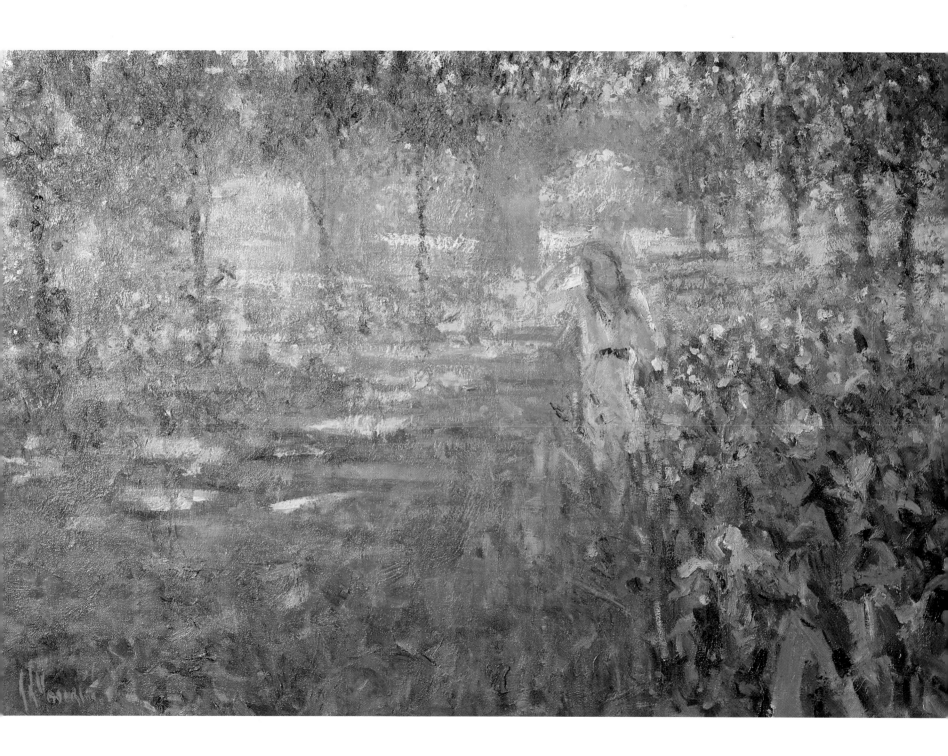

Arthur Maderson

Arthur Maderson is a Londoner who describes his roots as a mixture of working class, inner-city 'survive or go under' culture, which was modified by the influence of a father who was one of a tiny minority to win a scholarship to a private school. Arthur Maderson's path to professional painting has been hard – even tortuous. It started off conventionally enough with four years at Camberwell Art School; then came five years of various part-time jobs which included barman, grave-digger, night telephonist, chess tutor, bouncer and street trader, before he took a position as an art therapy teacher at a psychiatric hospital for nine years. This was followed by two years as a tutor at the British Institute for Brain-damaged Children.

During these twenty or so years, he painted in his spare time but, incredibly enough, he says he burned everything he produced. Then in 1982, when he was forty and living in Somerset, a decision to exhibit his work was finally forced on him, when a local watercolourist, unable to fill his previ-

◁ TOWARDS DUSK, DORDOGNE
32 x 48in (81 x 122cm)
A very gentle scene, lit by the evening sun. There is a wealth of subtle detail here, such as the distant bridge and the tiny child on her mother's shoulder, which demands the viewer's concentration, after the initial impact of the colour. The orange is so effective against the complementary mauves and blues.

ously booked gallery, asked Arthur to share his exhibition at Glastonbury. This proved to be a breakthrough, and from that time his rise in popularity has been meteoric, with highly successful exhibitions culminating in three one-man shows in London at the Alpine Gallery and, more recently, a major 'sold out at the preview' exhibition at the George Gallery in Dublin. Since 1986, he's exhibited at the Royal Academy, and the Royal West of England Academy.

In 1987, he moved with his family to an isolated farmhouse in the Cambrian mountains of Wales, and in 1989 he finally settled in a beautiful part of Ireland, Coppoquin, Co.Waterford, where he has a studio overlooking the River Blackwater. Ireland has rapidly had an intoxicating effect on Arthur, and he's realising his lifelong ambition 'to see out my days in Ireland'.

From what you've already read here, you'd expect Arthur's personality to be charismatic, even slightly eccentric – you'd be right! He has never owned a watch, and often has no idea what day, month, or year it is. His children recall being sent off to school on Sunday and kept home on a Monday. The idea of a holiday, so important to most of us, has never occurred to him. This timeless, no future, no past, lifestyle, and his fierce independence, is an attitude which many outsiders, including art dealers, often find exasperating.

He has a wondrous way with words; for instance, he described his feelings in his studio:

Early morning, the room full of dazzling sunlight, my head swimming with strong coffee and masses of ideas, no force is capable of bringing me to earth. Today I shall fly, hovering like violet between pain and pleasure, anxiety and elation. Painting for me begins with a surge of adrenalin. Initially, lemon yellow adrenalin born of high expectations as to what might happen, then the blood-warm adrenalin of sheer and absolute panic when your painterly world starts to fall apart, and on rare occasions, honey sweet adrenalin when, for a few moments, you feel the Gods are with you. The end product, or picture, remains a tangible evidence of this act. The debris of struggle.

For Arthur, painting is essentially an emotional act, an act of loving. He quotes Sigmund Freud who said, 'A great quest for power has been the prime motivating force in creativity, but it can equally be seen not

111

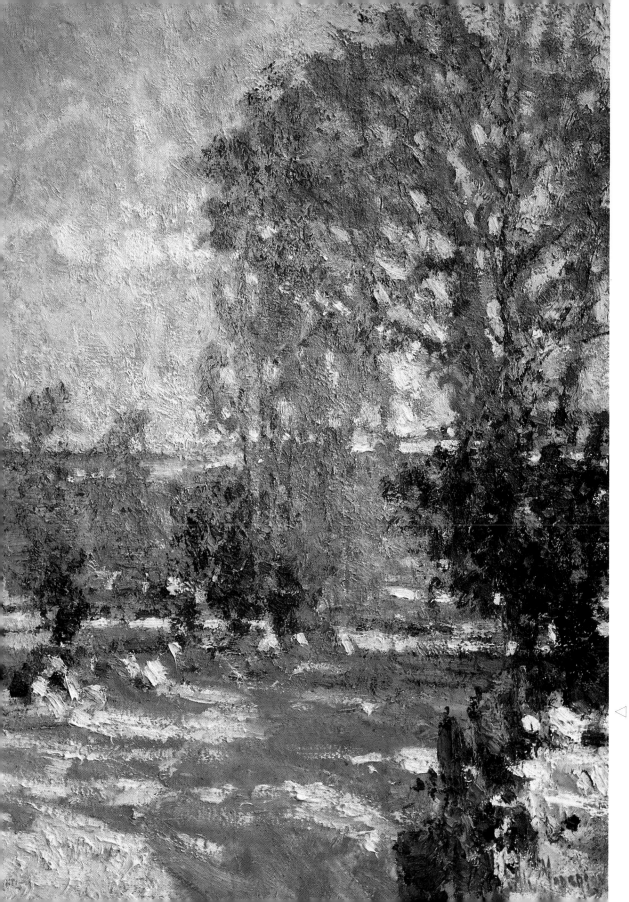

as a substitute, but a form of making love, which can last all day.'

Arthur has strong ideas about his role as a painter. He does not comfortably confirm what he feels others may see in nature, but is concerned solely with those changes he has previously failed to see. He believes that while we have an intellectual understanding of the 'separateness' of objects, they arrive on our retina in a fully integrated and delightful state of chaos. To resort to illustration in order to give spectators an easy ride is to insult their visual intelligence, an intelligence which actually thrives on the mysterious process of scanning a wide range of possibilities. Pictures are fuel for the imagination. He feels that the spectator's role is changing rapidly, acting no longer as the detached observer of other people's skills, but rather as an active participant in an experience which goes far beyond those sensations which meet the eye.

He distrusts painting on site, and says: 'Although I make frequent references to the subject, I return to my studio to paint. Being constantly in touch with the real world holds a tyrannical power over me. The temptation to look at objects rather than see the totality is overwhelming. I start to make chairs, sofas and windows which I feel are best left to carpenters and upholsterers. My job is to make a painting.'

Arthur believes that form can be suggested, not by direction of lighting or chiaroscuro,

◁ WINTER SUNSHINE
22 x 16in (56 x 40.5cm)
This painting has a cool atmosphere, with a simple touch of warmth in the centre tree, which is repeated in the sunlit branches of the foreground trees. The shadows on the snow take the eye into the picture.

but by variations in colour modulation. He also believes that it is possible to get closer to the richness and intensity of colour found in nature, not by tonal matching of the values, but by the sheer force of colour contrast. By sub-dividing an area of nature into its component parts it is possible to produce an active, energised and a subtle surface. There is no better way of ending this chapter than by quoting Arthur Maderson himself who feels personally that there is no finer activity than painting:

It grows with us and we grow with it. Long after the earthly power of politicians is relegated to a few lines in the history books, and the wealthy have come to dust, people will still be looking at a Rembrandt; he will remain more loved and powerful than any politician or businessman ever was.

△ BANKS OF RIVER BLACKWATER
35 x 37in (89 x 94cm)
Look at the shimmering web of colour which Arthur has created here by mixing complementary hues which intensify each other. I love the feel of reflected light on the boy's shadowed body, contrasted against the distant river.

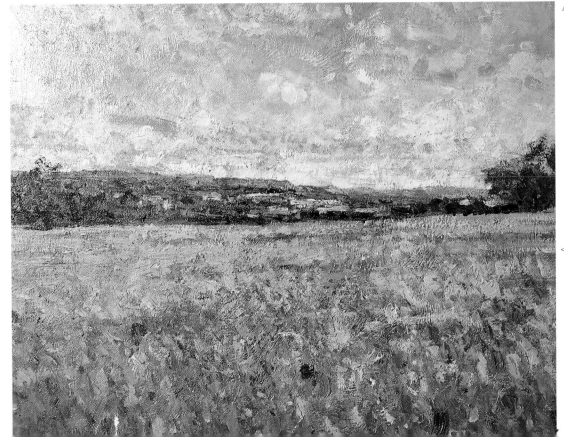

◁ EVENING SHADOWS, HAY-ON-WYE
25½ x 32in (65 x 81cm)
Arthur has juxtaposed orange and mauves to create this haze of colour which is even reflected in the gentle light of the evening sky. His paintings have so much of the quality of the original French Impressionists.

SEPTEMBER EVENING, NEAR BALLYDUFF ▷
(COUNTY WATERFORD)
28 x 36in (71 x 91cm)
The strong rhythms and patterns in this painting, which revolve around the complementary relationship of orange and blue, make this an enormously exciting and satisfying picture. The constant rhythm is relieved by the calmness of the evening sky.

▽ LISMORE FÊTE
45 x 49in (114 x 124cm)
Although painted in the shade, there is a wealth of warmth and colour in this delightful scene of his children picnicking. The feeling of tenderness, so apparent in many of Arthur's paintings, is very much in evidence here.

△ ARDMORE BEACH, NR. SUNSET
8½ x 6½in (21.5 x 16.5cm)
Here Arthur has produced a low-key painting using closely related shades of colour which effectively portray the feeling of the evening light on the wet sand.

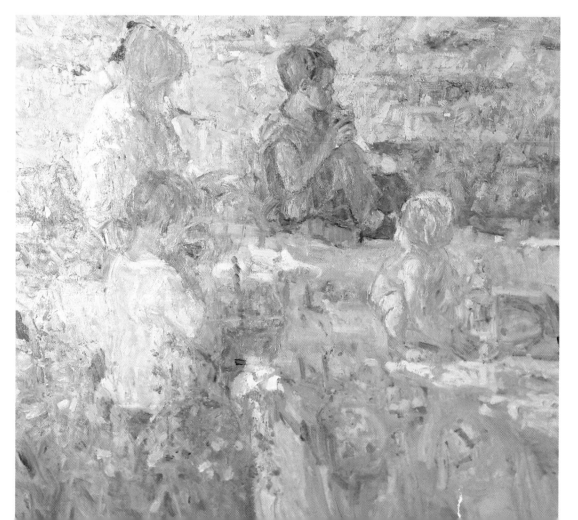

Pier Luigi Baffoni ROI, NS

In writing this book I've learnt much from each individual artist I've studied, trying to delve into their personalities and their methods. Obviously when I've been able to meet them personally it has been easier, but unfortunately, due to the vast distances involved, many times I've had to read and re-read their own thoughts on paper to get to know them.

With Luigi Baffoni, for example, one

FRUIT AND FLOWERS
20 x 24in (51 x 61.5cm)
Although this painting is a riot of colours, they have been controlled and balanced in a masterly way. The distant view through the window has been cooled down, whilst the foreground still life has been painted in rich warm colours. The window frame provides a strong vertical element.

feels that this artist is continually searching for vision in his work. This is revealed in a very thought-provoking article he wrote recently. One has only to read it to begin to question one's own attitude to painting. He says that once an artist has been painting for many years, he must stop every so often and consider – is my work improving, stationary, or even deteriorating? Of course, with time, one gains experience and, with that, greater technical competence. But what one needs to ask oneself is if, with this improved technical ability, the original emotional powers, so vital to true artistic expression, remain. Of course artists must improve their means of expression, but it's vitally important that they also refine their sensitivity. The fact that an artist has painted for many years and has dedicated his life to art, needn't necessarily be significant. Improvement has less to do with time worked than with his capacity for renewal of vision. Painting, like other art forms, is a product of the spirit and requires constant spiritual renewal for genuine artistic expression.

The previous paragraph has shown the sensitivity and sincerity of the man but, before discussing his methods, let's go back to his beginnings. As his name implies, Pier is Italian, born in Turin. His family had a strong tradition of painting. Grandfather, uncles and brothers all painted. Surrounded by such an atmosphere, it was perhaps inevitable that he should become keen on painting and familiar with different media.

In his family home in Turin, the loft was his retreat, and in its dust and heat, during

the long school summer holidays, he started painting with all the art materials he found up there. His first subjects were still-lifes and portraits in oil, but he soon graduated into landscapes. It was in the Italian Alps where he found his inspiration – from mountains, streams, woods and fields shimmering in the hot sunshine, as well as from constant visits to the studios of his accomplished uncles.

Other Italian painters influenced him too, such as Nino Springolo, Juti Ravenna and the Venetian, Alessandro Pomi, all three remarkable for the variety and richness of their work. There was, in fact, a strong school of Italian Impressionists called the 'Macchiaiolli', which together with the French and Post-Impressionists, influenced him greatly.

He's obviously a figurative painter, with a great love for tradition. His natural flair for colour is evident, and he has developed this sense of colour over the years. He has always been interested in the temperature of colours, which were predominantly warm and even hot during his early years in Italy. Then came what he calls his many fresh starts, and the renewal of vision, which we talked about earlier.

Pier decided to come to England in 1973, and married Mary, a teacher, a freelance sub-editor and part-time potter. Whereas the dryness and stillness of the Italian landscape allowed for prolonged contemplation, interpretation and perhaps a more abstract vision of the scene, here in England he had to rethink and deliberately cool down his

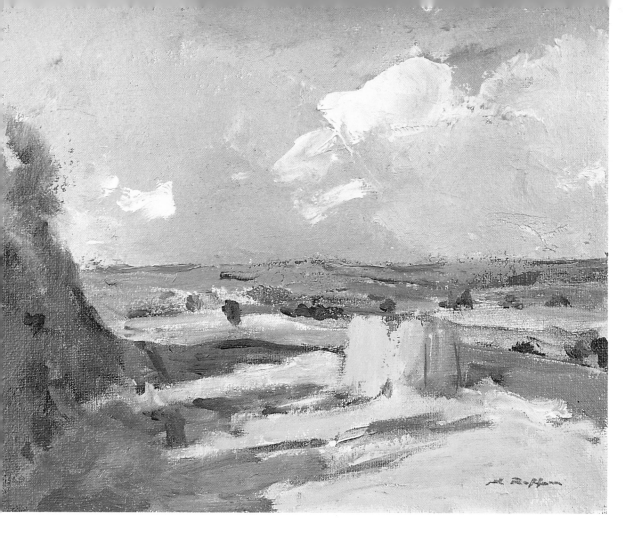

PUMPKIN AND NASTURTIUMS ▷
16 x 20in (40.5 x 51cm)
This painting makes an enormous impact, glowing with the brilliance of a stained glass window – just look at that blue of the vase! The virtually plain yellow of the pumpkin is a good foil to the complex colours of the flowers. Notice how the two elements have been linked by the overlapping flowers.

colours. Also, the difference in scenery and the difficulty of the climate led to more regular painting in the studio. Having to establish contact with the unfamiliar forced him to draw much more, and this habit has proved valuable in his constant search for renewal. Before every finished painting he attempts, comes this careful build up of information for consideration and analysis. The end result is of deceptive spontaneity and simplicity of statement. Another way he continually awakens this enthusiasm, is to

△ CORNFIELDS
8 x 10in (20 x 25cm)
This picture is as full of colour as any French Impressionist painting – even the shadows are singing as they lead the eye into the rest of the picture. The clear yellow of the corn is intensified by the reds and blues surrounding it. The sky, too, has been put in with enormous verve and freedom.

AUTUMN, ALPS, ITALY ▷
10 x 12in (25 x 30cm)
The bright green foreground vibrates against the complementary reds of the trees. Pier has used pure colour here, even a patch of purple, to heighten the impact. The sky, blends and echoes the feeling of the landscape.

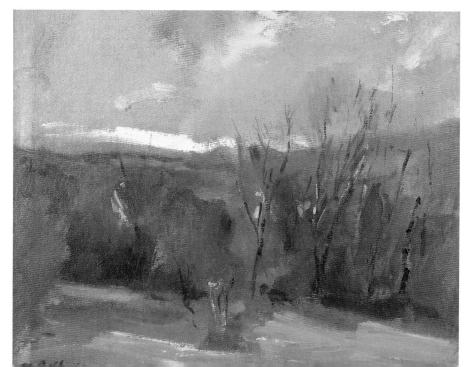

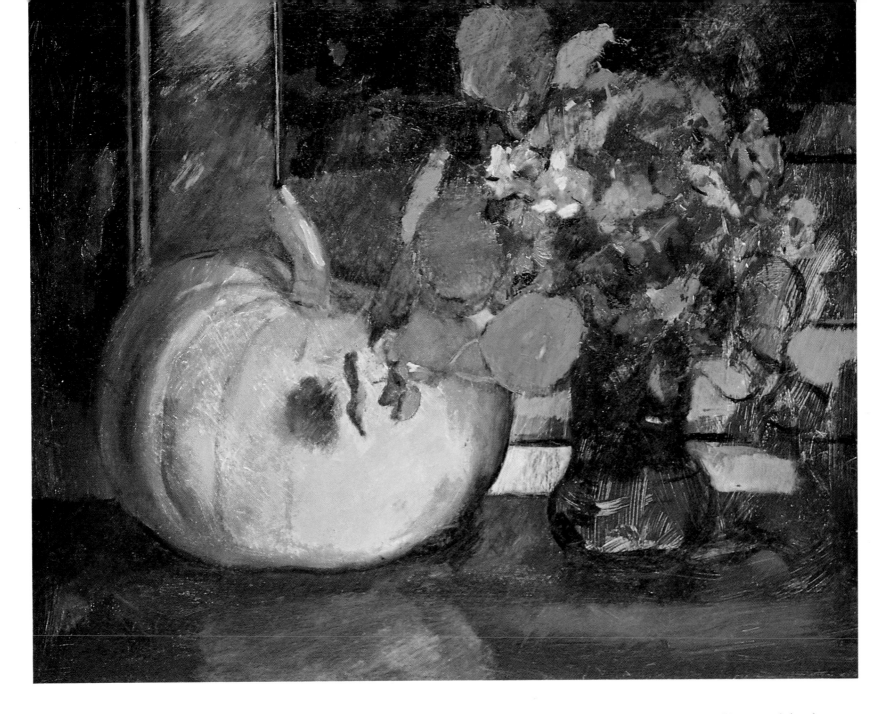

vary his subject matter and move from one medium to another.

He particularly loves still life, which many of us might consider too static a subject to paint, because he feels it enables him to have greater freedom and control over his composition and light source, whilst also offering him the possibility of endless contemplation. He feels, above all, that time spent thinking about the subject itself provides inspiration, and power of abstraction. Even when he paints a landscape he tries to capture the stillness and timelessness of a still life in it. Pier Baffoni is a very sincere painter who's constantly trying to avoid the danger of sticking too rigidly to self satisfied formulae in painting – perhaps a lesson to us all!

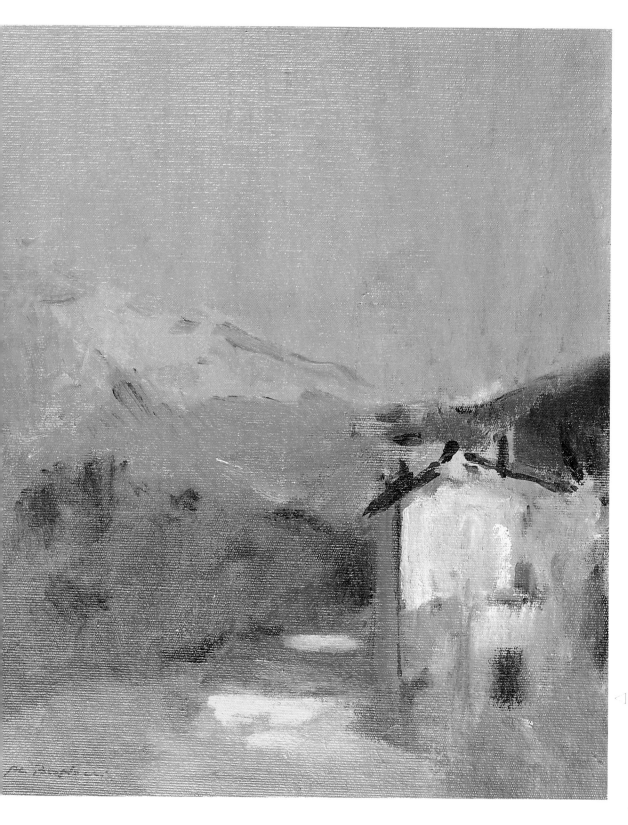

AUTUMN, ITALIAN ALPS
12 x 10in (30 x 25cm)
This strongly composed painting has been reduced almost to an abstract. The balance is perfect and thoroughly satisfying. The restful but subtle tints of the sky complement the richness and boldness of the colours below.

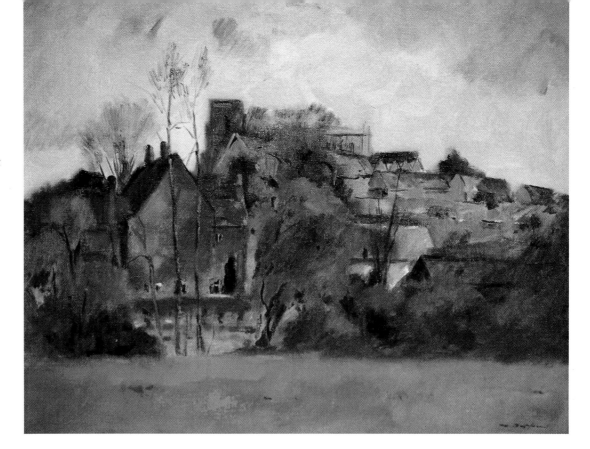

SHILLINGTON, BEDFORDSHIRE ▷
18 x 22in (46 x 56cm)
This is a more gentle and contemplative painting than the one on the opposite page. There seems to be a patch of sunshine striking the centre of the village, with the rest of the picture in a more subdued light which enhances the counterchanged barn in the middle left of the painting.

▽ EVENING LIGHT, ITALIAN ALPS
12 x 24in (30 x 61.5cm)
This painting glows with a riot of warm colour, reflecting the hidden rays of glorious sunset and showing the effect, rather than the cause. Just let your eyes feast on the richness and variety of pigment here. Note also how the sky blends in subtly.

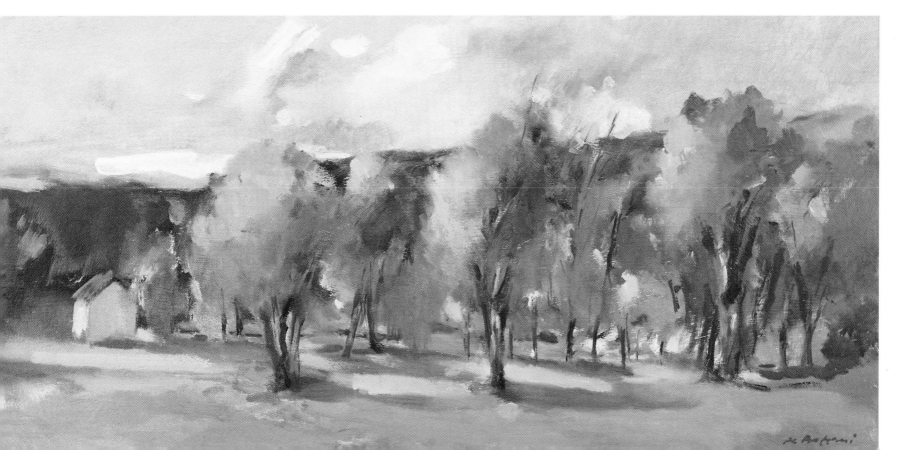

Lee Gordon Seebach

In compiling this book, I've written to artists all over the world and received the utmost co-operation from them, proving yet again the generosity and fellowship of painters which transcends borders and nationalities. Many, however, whilst willingly and trustfully providing their precious transparencies, have been reluctant to expose their thoughts and feelings about their work. Not so with Lee Gordon Seebach, who sent me 28 pages of typewritten notes and, to do him justice, there's no better way than to quote directly from his writings. In fact, I wish there was the space to use them more fully.

But first, let's talk a little about him. Lee Gordon Seebach was born in Waterloo, Iowa, on 22 July 1950. He grew up on the family farm near Dysart, Iowa, where he had a rigorous boyhood of hard work and hard play. At an early age, Seebach followed his natural inclinations toward art and music. He actively studied both areas of interest throughout his prep-school years, taking art classes, drawing and painting in his spare time, playing the alto saxophone in school orchestras and bands, and occasionally playing the piano and guitar for his own amusement. Today, classical music, philosophy, literature, the five-string banjo and tennis are sources of inspiration and release from the pressures of his busy career as an artist.

From 1968 to 1972, Lee studied at the American Academy of Art in Chicago under Douglas R. Graves, Bill L. Parks, Joseph Vanden Broucke and Irving Shapiro. At the Academy, his major focus was on life draw-

ing, human anatomy, still-life and portrait painting. After graduation, he continued his study of portraiture and figure painting at the Palette and Chisel Academy of Fine Arts. He began painting landscapes *en plein air* in 1974 in the Chicago forest preserve areas, along Lake Michigan, on the city streets and in the suburban countryside. In 1979, Seebach moved to Arizona where he painted for five years in the Sonorran desert, the Sedona/Oak Creek canyon area and in the streets of Phoenix. Then in 1984, he moved to Taos, New Mexico, where he continues to live and work.

He's highly critical of his own work as well as that of artists who he feels try to achieve fame too quickly: 'The average student wants shortcuts, and often will try to copy a master's finished work,' he says, and continues:

What the student does not realise is that a master took the long road, no shortcuts, and gained his mastery through study, discipline and practice. The student wants to skip over all that and get right to the end of the journey. A master's work is the reflection of many years of experience, accumulated emotions and maturity. The student can't skip over the often painful intermediate steps. You can't simply pick up a violin for the first time and perform at Carnegie Hall, or put on ballet shoes and perform in Swan Lake, any more than you can pick up a brush and be an accomplished painter. Years of training and discipline are what is required.

He feels that as a result of this, the galleries are today filled with paintings and drawings by artists who do not have the skill, understanding, training, insight and wisdom which can only be gained through patient and careful study: 'You can't express yourself without these tools, for ineptitude stands between the artist and expression.' Of his own work he says:

WINTER IN PILAR ▷
24 x 24in (61.5 x 61.5cm)
I wanted this painting to be reproduced as large as possible, so that the reader could appreciate its exciting brushwork and boldly contrasting colours. It will be no surprise to learn that this painter works in the same area as Walt Gonske (pages 102-9). There's a strong zig-zag movement in this painting.

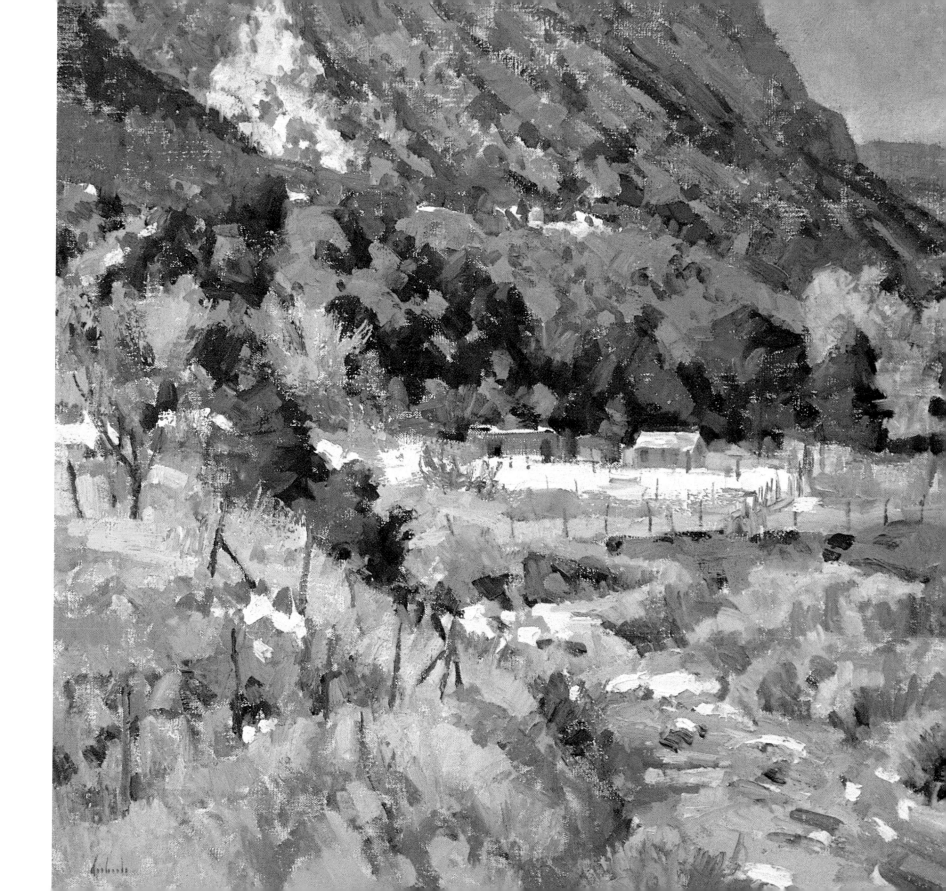

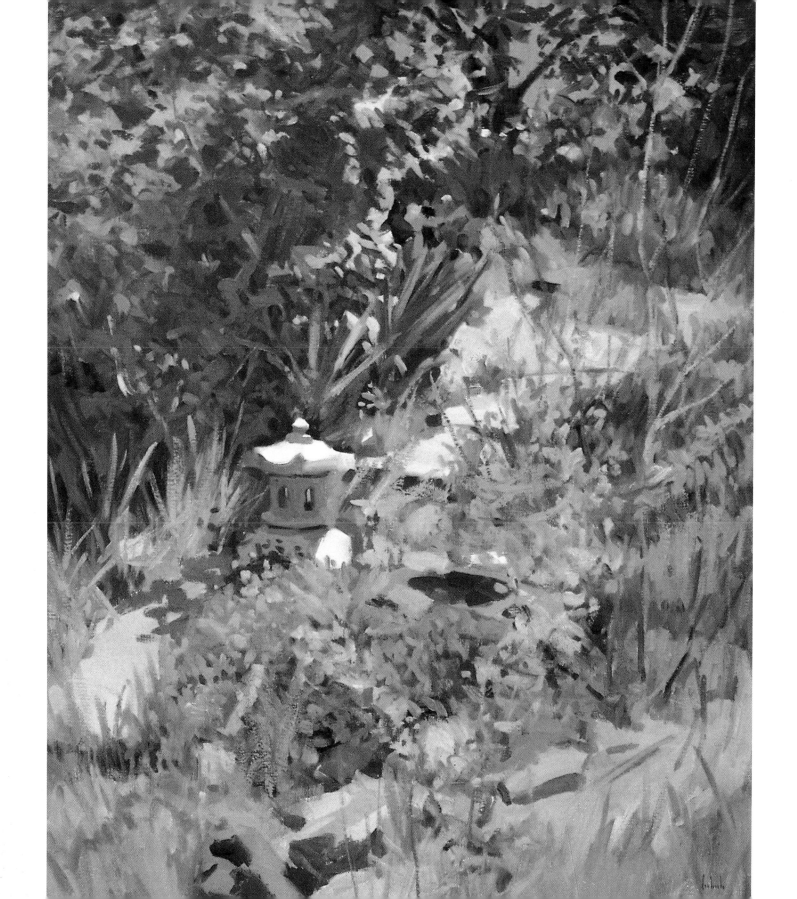

I would estimate that out of every 20 paintings I attempt, I save 10 (the rest are wiped out or destroyed later), four of which I like a great deal and six of which I like moderately. I would say about one out of 50 will amaze me and astonish me enough to rank among my very best efforts. These averages are not something I choose, but are simply the way I learn and grow. My failures are invariably learning experiences, which prepare the way for future successes, and my successes are a cumulation of what I recently was trying to master; and then I go back to learning again. It's a cycle of achievement, not unlike any other area of endeavour, and when you come to understand and accept your own patterns of growth (which, by the way, will be unique to you), it is much easier to accept the failures in painting as learning experiences. It is a mistake to think that good artists never fail. In fact, the best among us may very well destroy much more work than one might imagine. It is because their standards are so high, which causes them to be so critical of themselves. It is the artists with low standards who save everything they do, because they don't understand – or will not admit to themselves – the difference between what is 'good' and what is 'not good'.

Seebach feels himself to be a perfectionist student:

Painting should be an ongoing *study*. Learning must never cease. For myself, I don't concern myself with whether or not the work I do is 'art'. I work to please myself, pursuing whatever goals I set. Mine is a fascinating, challenging, personal journey of discovery, achievement and expression. The secret is to keep believing in your dreams, and do whatever it takes to make them come true.

Painting techniques are a means to an end, and should not call attention to themselves for their own sake. The value of one's technical style is tested primarily by its degree of effectiveness in relaying its intended message or meaning. Lest you get the wrong idea, I am *not* saying that fine painting is a mere trick of the wrist, nor is it simply a matter of an imaginative technical performance. Far from it. True virtuosity and excellence in

◁ NAN'S GARDEN
32 x 26in (81 x 66cm)
There's a very definite diagonal design in this painting, centred around the top-lit garden ornament. The predominant colour, which is many shades of green, is further enhanced by the touches of complementary mauves and pinks. Again the brushwork is particularly bold but well controlled.

HEAVY ATMOSPHERE ▷
24 x 30in (61.5 x 76cm)
Lee has used colour in this painting to produce a definite feeling of foreboding and approaching storm. He has also created a sense of infinite space and depth by the use of aerial perspective. The tiny touches of red add excitement.

painting is the result of self-confidence earned from experience and backed by sound painting knowledge. Painting techniques are simply the means through which the painting message is conveyed. However, it is necessary to study the technical aspects and the possibilities of painting in order to express meaningful ideas. It is also necessary to have something worthwhile to 'say'. Expression of feelings or emotions are just as necessary to excellence and beauty in painting as technical knowledge. Unless one experiences feeling toward the subject, and gets an emotional thrill or charge from it, the painting can become a technical performance, lacking emotion.

In my painting, I have found it very beneficial to my growth to 'slow down' sometimes and study. Without taking *too* much time and getting *too* wrapped up in a painting, I still want to focus my attention, and usually this is done with still-life painting (though not always). In the studio, away from the myriad of variables which outdoor painting presents, I can control conditions much more, which gives me the opportunity to take my time, slow down and reflect a great deal more on what I am doing. Again as a student of painting, I am primarily interested in my growth, ie doing more beautiful work. As I once heard quoted, 'The biggest room in the world is the room for improvement'.

It is better to have a smashing success than a timid, semi-success. Paint directly and boldly so that your successes are obvious. If it is right, it will scream out that it is right. On the other hand, if it is wrong, it will scream out that it is wrong. By being able to identify clearly between the two, you can make progress faster. Do not sneak up on painting, but have the courage to approach it with confidence. Your paintings will reflect boldness and clarity. Once you have learned to paint with boldness, you will know the difference between timidity and subtlety.

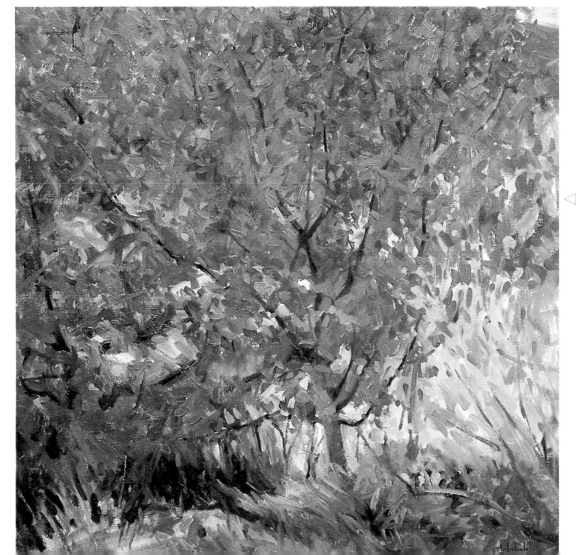

◁ RADIANT FLOWERING CRAB TREE
28 x 28in (71 x 71cm)
The colour here is almost breathtaking, completely dominating the picture. It has obviously been painted in a state of high excitement. There's nothing subtle here – the paints could have come straight out of the tube, to thrill and delight us.

POPPIES AND DELPHINIUMS ▷
24 x 30in (61.5 x 76cm)
In contrast with the picture on the opposite page, this flower painting seems to have a much calmer atmosphere, although it is still full of vibrant colour. The brush strokes, too, appear to be more considered. Compare these two paintings for yourself.

Index